LIGHT
IN THE
NORTH

Spring 1992

To Mum and Dad,

Here's to a happy holiday
in Orkney.

from David and Heather,
Andrew and Edward.

LIGHT
IN THE
NORTH

St Magnus Cathedral
through the Centuries

Edited by
H. W. M. Cant and H. N. Firth

Illustrated by
Isobel Gardner

THE
ORKNEY
PRESS

Published by The Orkney Press Ltd.
12 Craigiefield Park, St Ola,
Kirkwall, Orkney.

Published 1989.
ISBN 0 907618 22 7

Designed by Iain Ashman

Printed in Orkney
by The Kirkwall Press

Cover Painting:
'Kirkwall in the Orkneys'
by Stanley Cursiter.
Reproduced by kind permission
of Tankerness House Museum,
Kirkwall

The publishers wish to thank
Orkney Islands Council for
financial support which made
possible the production of
this volume

CONTENTS

FOREWORD
R. A. A. S. Macrae

It may surprise some that so many wise and distinguished men and women came to Orkney in 1987 to honour the 850th anniversary of the founding of St Magnus Cathedral with their eloquent and learned words.

Light in the North is the record of their coming—aptly named, for so it has been down the ages. *The Loom of Light*, wrote George Mackay Brown for his story of the martyrdom of St Magnus.

So it has remained, but not without the dedication and perseverance of so many through time and weather.

An act of faith it was in the beginning, and continued to be over the three hundred years it took to complete the building, many setbacks being suffered on the way.

At the beginning also, it was a place of pilgrimage—so numerous being the throng of pilgrims that normal services were severely interrupted and special arrangements had to be made. Canterbury no doubt had the same problems.

The importance of St Magnus Cathedral to Christianity in the north cannot be underestimated. It is unique, of course, in being a church belonging to the people since its assignment by King James III of Scotland to ownership by the community of Kirkwall. This has perhaps been its protection from the excesses of the Reformation. The property of the magistrates, councillors and community of a Royal Burgh could hardly be destroyed to satisfy religious fervour.

Christian worship in the Cathedral remained uninterrupted down the centuries and, in the fairly tolerant Orcadian manner, alternated between Episcopal and Presbyterian as men disputed the form of Church government.

In modern times this has been resolved although, quite rightly, the building can still be used as a place of worship by Catholic or Protestant alike when circumstances dictate—again part of the lasting strength of St Magnus.

The worldwide importance of St Magnus Cathedral became clearly apparent in the latter part of 1971 when it was found that the west gable would collapse into the street within five years if nothing were done. An appeal was immediately launched and a press conference held at the start of the following year. This was attended by leading correspondents from all the national and Scottish newspapers, as well as the BBC and the *New York Times*. They arrived by air on one of the very worst of Orkney's January days—driving winds of sleet and snow with a cloud base alarmingly low. After an appalling flight and nerve-racking landing, they came straight to St Magnus Cathedral to be greeted by Lord Birsay in the warmth and beauty of the Cathedral nave. Stripped of the encumbrances of chairs etc., but with the vaulting floodlit and highlighting the joy and welcome of the place, it was quite breathtaking.

St Magnus Cathedral is grateful to those correspondents who braved the storm and gave worldwide publicity to her problems. In the first day £4000 was raised locally, and in one year enough money had been donated to enable work to go ahead and save St Magnus.

The importance of this great church was also nobly underlined during the 850th anniversary celebrations when Her Majesty the Queen honoured Orkney with a visit to unveil the new commemorative window in the west gable. This remarkable stained glass window, by the artist Crear McCartney, was paid for entirely by local subscription. Also during these celebrations, Her Majesty Queen Elizabeth the Queen Mother, as Patron of the Society of the Friends of St

Magnus Cathedral, received His Majesty King Olav of Norway at Kirkwall Harbour. Later, as a service in the Cathedral, King Olav presented Queen Elizabeth with a tapestry, the gift of the people of Norway to St Magnus.

This unique—almost 'mini'—Cathedral, which has stood for so many years as evidence of our Christian faith and love, will stand for countless centuries yet, given the devoted support it has always received. These things are well recorded within these pages.

It is sad that two who worked so hard towards these cultural celebrations of the founding of St Magnus Cathedral, the Reverend Harald Mooney, Historian and Friend, and Colonel Reg Bond, Session Clerk, died so soon after this event.

In conclusion, therefore, I pay tribute to their memory.

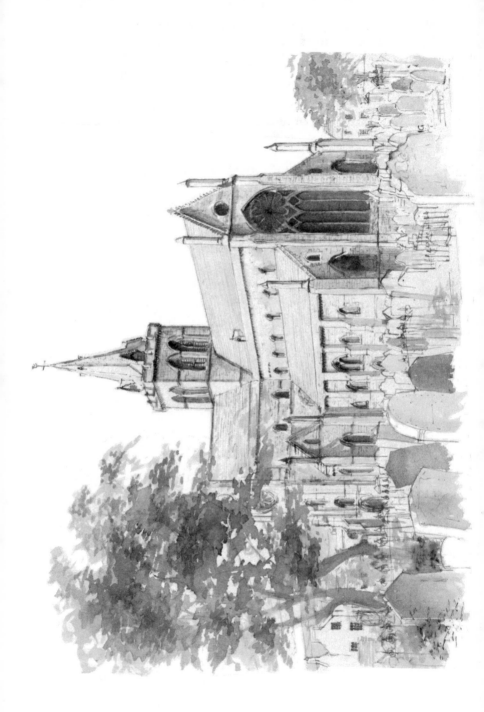

THE ORIGIN AND CONTEXT OF ST MAGNUS CATHEDRAL
H. N. Firth

"There is something in their church," wrote Storer
Clouston as a young man, *"that none of the respectable
townsfolk have the slightest suspicion of—something alive that
vibrates to the cry of the wind and the breaking of the sea, and
the little human events that happen in the crow-stepped houses."*[1]

How any cathedral got built is a remarkable story: the
sheer technical challenge made it an enormous
undertaking. For a small town like Kirkwall in a scattered
island group on the north-west edge of Europe to have its
own cathedral—alongside for instance Chartres, Rheims,
Cologne, Winchester, Salisbury—something extraordinary
must have taken place.

The development of cathedrals is part of a great
interweaving of relations between Church and State. The
spires reaching heavenwards express a piety and clarity of
spiritual thought towards the world above; the rock-solid
supporting pillars and carefully-designed load-bearing arches
represent the outcome of a massive channelling of the skills
and resources of this world. The end and the means come
together in a great 12th-century flowering of life in western
Europe that continued into the following century and
produced over 500 cathedrals.

The great fabric of society of medieval Europe was the
Christian Church:

> It was Christianity that gave medieval Europe its
> identity and unity; from Iceland to Sicily, from
> Portugal to Finland, you could go into a church and
> attend a service in which the ritual and the language
> were largely the same.[2]

The idea of using the Christian religion as a unifying

force, underpinning the structure of the secular world, came—like so much else in Church structure—from the Romans. In the 4th century AD the Roman emperor Constantine saw the growth of the new religion as a force for order, to hold together the old and decaying empire and give it fresh vigour and internal fibre, and a number of the main features of organised Christianity grew up from the base he built.

> It was he who gave the Lateran Palace to the bishops of Rome as their official residence, and built the first church in Rome there, using as a model the classical public building known as a basilica, a spacious hall with a wooden roof . . . Constantine wanted a unified church, obedient to the emperor. As part of that policy, he promoted the bishop of Rome's claim to be *Papa* or pope, final arbiter of disputes and ruler of a single church.[3]

The administrative structure of the Roman empire was thus used as a mould for the emerging Christian Church, the church itself being envisaged as a template on which a new order and organisation of society would emerge out of the ruins of the old, in a process of revival and renewal.

> The apostles had been missionaries; their successors, the bishops, were leaders of local churches, based on areas that often corresponded to the divisions of the empire. 'Diocese', which we use today to indicate the area under a bishop's control, meant originally a group of imperial provinces.[4]

The bishops began by moving around their dioceses, but in time established permanent bases, often in the old Roman centres of administration, the cities. The bishop's seat was his *cathedra* (from a Greek word); and the bishop's church, his *cathedral*. (The word 'seat' also appears in the term 'see' for the territory supervised by an archbishop.) Thus, just as the physical buildings of the new Church often grew out of the ruins of old Roman buildings, so too did the adminstrative structures. Hence the concept that a city is defined by the presence of a cathedral, and the use of the word 'metropolitan' for the authority of an archbishop.

While the Romans were building in brick and stone, the people of northern Europe used timber from the forests for their long, barn-like halls, where the roof was held up by tall, squared-off wooden posts. The Romans preferred stone for their own roof supports, following the Greek style of two rows of round stone columns, set closely together. On the top of each column was a large stone block, called a *capital*, to take the weight of the stone beams above.

There was a kind of parallel in the Northern and the Roman concepts of the religious significance of the long building. The northern hall was dark and smoky, with the only natural light coming from a couple of smokeholes in the roof, the rest of the building being designed to keep out the weather. But the idea of a bird entering from one end and eventually departing again through the other, as a metaphor for the human soul travelling through life, from an unknown origin to an unknowable destination, found ready response when cited by an early Christian missionary to the Northumbrians.

To the Romans, the body of the church was also a channel for something passing through, but in the opposite direction. The light of Christianity was let into the building from the one end, at the east, and poured in to fall upon the people within, as grace from above. The churches were aligned east and west, with the rounded eastern end or *apse* containing the altar on which the light would shine. The main body of the church was called the *nave*, the same word as the Latin for 'ship'; one can think of the shape of the roof timbers as like those of a longship, or else return for a moment to the idea of the soul's journey through life, as a bird in flight, or a ship's course through a great sea.

But it was important for the early Roman churches to admit the light, and this concept was built into the design.

> There were good windows with the glass in them; and so that the middle part of the church should not be too dark its roof was raised higher than the roofs of the 'aisles' on either side by building stone walls, with windows in them, upon the two rows of columns which passed down the building. The part rising above the side roofs and carrying the main roof is called the 'clerestory'; it always has windows in it.[5]

7

The Roman Empire, formally divided into two halves in 395, did not long survive in the west, where its decay proved irreversible. But Constantine's incorporation of Christianity as a strengthening fibre for society enabled a degree of order to prevail throughout the period of imperial collapse. The eastern, or Byzantine, empire held together—incredibly, for a thousand years—and it developed its own type of architecture for sacred buildings. The Byzantines drew on the eastern tradition of roofing buildings with great stone domes, and so their churches tended to be round or square, rather than long and rectangular like those of Rome.

> As there was a heavy stone dome to carry, instead of the timber roof of the Roman church, the Byzantines dared not use slender columns, which would never have borne the weight; they used, instead, huge masses of stonework called 'piers' between which very large arches supported the dome above.[6]

So one more thread took shape in the eventual pattern that was to develop into the medieval cathedral; the technique of supporting a mass of heavy masonry that was not simply directly above the support. The arch took the weight of the central dome, and transmitted the load down onto the piers. The high central dome rising above the squarish body of the church became in western Europe the central church tower.

The Roman arch developed further under the great Islamic civilisation. The furious advance of the Moors threatened for a time Christendom itself; but in the longer term it brought a marvellous infusion of learning and culture into Europe. Tier upon tier of arches rise upon each other in the palaces and mosques of Moslem Spain. The mathematical and architectural skills of the Moors enabled them to find solutions to technical problems of arch design and vaulting which gradually spread through Europe in succeeding centuries—a Europe in which the need for a strong Church presence was reinforced by the very pressure of the Moslem world on its borders.

The onward sweep of the Moslems restructured Europe. By taking control of the Mediterranean, they cut trade routes, and isolated the northern countries. The outcome was

the development of alternative northern foci of trade, on river or coastal sites (the old Roman roads having fallen into decay). New trading sites were founded in areas like East Anglia, Southampton, the Channel coast of France, and the mouth of the Rhine. As in Roman times, manufactured goods were traded for the raw materials of the north.

The pattern of trade was very much controlled by local rulers, continuing the ancient tribal role of the king as ring-giver, and avoiding the independent growth of wealth in the hands of any of his subjects. So trading was kept to specific places, under close royal control, and the trade itself was often carried out by alien merchants: first Friesians, and then Norwegians and Swedes.

The use of foreigners was also useful when it came to opening up indirect trade links with the Moslem world. Hence the development of the Swedish route through the Baltic and down through Russia and on to the trading centres of the Caliphate of Baghdad.[7]

At the centre of this great period of transition were the Franks. In 732 their king Charles Martel had stopped the Arab advance in battle at Poitiers, and his grandson Charles who became sole ruler in 771 went on to set up a new empire that has been aptly described as the 'scaffolding of the Middle Ages'.[8] To France he added territory that reached to the Pyrenees, northern and central Italy, and northern Germany, and on Christmas Day 800 was crowned Emperor of the West by the Pope in Rome.

The Holy Roman Empire that Charles created was to survive, in one form or another, until 1792. Charles himself was deservedly known to his contemporaries as Carolus Magnus, Charles the Great, and to us as Charlemagne. He gave his empire the same strengthening force as the Roman Emperor Constantine had done five hundred years before, by making Christianity its spiritual fabric. This was the start of a great period of cathedral-building. Churches and monasteries were built too, and scholarship and the arts encouraged in the Carolingian Renaissance. For the Norse world, the Holy Roman Empire was the source of trading opportunities, and subsequently the main process of conversion to Christianity.

The Empire proved too much for any of Charlemagne's successors to hold in its entirety, but it continued to exist, coming by the 10th century to be centred more about the

restricted focus of Germany and northern Italy. But the model had been set, of the orderly administration of church and state in harmony together, and the pattern was later to be followed again—though in a sterner form—by the Normans.

Meanwhile European trade had been diversifying away from the Baltic, with the opening up of the western Atlantic sea-route. This development had immense consequences for Orkney, bringing increased Norwegian interest and eventual rule. One factor in the move away from the Baltic may have been the growth of piracy, especially around the islands at its mouth. The piracy grew into the big massed raids of the Vikings on settlements near and far. But there are signs that trade through the Baltic had been declining in the years before the Viking raids began, the supply of silver from the east being drastically cut down for a time by civil war in the Caliphate, added to similar disputes amongst Charlemagne's successors.[9]

The Vikings may thus have been a symptom, rather than a cause, of the underlying economic pattern; they may have moved from the Baltic, to go to where better pickings were opening up. There is some irony in the extent to which their name has survived from this period, when they were so totally alien to every aspect of the life of the times.[10] The Church was such a part of the order and stability of this world and the next that to attack its buildings and massacre its priests was quite literally inconceivable, and that was why it caused such horror and revulsion.

To counter the Viking threat, kingdoms were brought together under strong new rulers, and these states became the national units of the Middle Ages. Amongst the rulers who emerged from the onslaught was Alfred in Wessex. Harald Fairhair built a strong Norwegian state with a rigid system of law covering every aspect of the sea and ships; he also cleared Orkney of Vikings.

As the central authority of the Holy Roman Empire weakened, France began to suffer badly from raids from the north. In 911 Charles the Simple of France found an answer, the application of an old Roman technique of turning the poacher into a gamekeeper. He made a deal with a leader called Hrolf or Rollo, whereby the latter and his followers were given the French provinces facing the Channel—the land known today as Normandy, the land of the Norsemen.

Hrolf may have got involved in raiding, but he came from a noble background. His father was Jarl Rognvald of Möre in Norway, a strong supporter of Harald Fairhair, the rank of jarl or earl being second only to that of a king. One of Hrolf's brothers had died in Harald Fairhair's service during the expedition to rid Orkney of Vikings. Hrolf's half-brother Einar had subsequently been sent back to Orkney as its Earl, and was showing himself to preserve order with an iron hand. That would have made a good precedent for Hrolf himself to settle down and do the same. Whatever the background, the king gave him his daughter in marriage, and Hrolf set himself to building up a strong and well-organised state on the basis of the older systems of order which had been there from Roman times through to the Holy Roman Empire.

> He not only shared out the new domains among his followers in an orderly fashion, but enacted laws to ensure peaceful possession. He arranged the new social hierarchy in a way which testifies less to the democratic society of the north than to a shrewd realization on Rollo's part of the possibilities of French law; in effect, he created a pyramidal structure in which his companions owed loyalty to him and in turn gave estates to, and received loyalty from, their own group of subordinates.[11]

> Normandy was born out of a mixture of Roman, Carolingian, Frankish and Scandinavian elements; a strange pedigree, but one which was to prove extraordinarily potent in the hands of its single-minded leaders.[12]

Organisation and order led to rapid Norman consolidation and expansion, to the point that in 1066 Duke William conquered England. He took control at the top, holding England not by force of numbers, but rather by putting key men in places of power, and reshaping institutions so that they kept all sections of society in their place. The feudal system of land tenure, the building of a network of stone castles, the organisation of towns and roads, were all part of the management system by which England could be run by a comparatively small number of

Norman administrators. William also used the Church as
part of his system of government.

A new hierarchical structure was established, with
Canterbury being given primacy. The seats of the bishops in
rural areas were moved into the appropriate major towns,
which with their new feudal lords and castles were focal
points of the Norman network of power. Church and State
thus reinforced each other with the move of the bishops to
growing towns like Lincoln, Norwich, Bath and Chester, and
the new pattern was given permanence by the building of
magnificent new cathedrals in the new centres of episcopal
power. In cases where the bishops' existing bases were
deemed satisfactory, their cathedrals were rebuilt.

The Normans were masters of cathedral building,
applying organisation and channelling resources to existing
ways of doing things, but also bringing in new ideas from a
variety of sources. Involvement in the Crusades, and rule for
a time in Sicily, Malta and along the North African coast,
brought them into contact with Moslem architecture, and its
use of complex geometric design and rich interlocking
colours. They also developed a liking for the English style of
decorative figures. So in many ways it was like a number of
tributaries being brought together into one great river, in a
glorious cross-fertilisation of architectural ideas.

Among the Norman developments is the building of
arches in semi-circular layers, one above the other, so that a
narrow bottom ring supports a series of wider arches above
it. This gave a stronger structure, and only required a narrow
wooden frame to be used for the setting up of the bottom
arch. They used this technique of 'orders' of arches for
windows, and also for doorways, where they carried the
arches right down to the ground on each side, enriching the
shafts of the arch with ornate carving.

The undisputed masterpiece of early Norman architec-
ture in England is Durham Cathedral. It was built to house
the bones of two great figures in English church history—St
Cuthbert and the Venerable Bede. But the political reason
for channelling resources into the project was Durham's
position as a frontier town. To build it up into a stable
outpost, the first step was to begin a castle, in 1071; the next,
in 1093, was to found a cathedral.

At Durham a great technical problem was solved for the
first time. Cathedrals were being built in two storeys, and

the floor of an upper gallery consisted of stone slabs. These had to be carried on stone arches, the original way being to build simply a long continuous arch running all the way along like a tunnel. This type of roofing or 'vaulting' was dark and gloomy but methods of bringing in more light were cumbersome.

The new method of vaulting which is first seen at Durham is ingeniously elegant. The weight of the ceiling is carried on a series of interlocking arches, forming a skeleton of ribs that cross each other in pairs, to meet at a single keystone. On top of these slender, graceful arches, an arched ceiling of light stone was supported. This ribbed vaulting is one of the many aspects of design inherited from Durham by St Magnus Cathedral.

Orkney by the 1130s had developed into a prosperous society, through its key position on the great western trading route from Norway. Ships had by the previous century developed into deep-draughted vessels with keels and sails, and Orkney's role as a way-station gave it an opportunity for a share in the wealth of the Norwegian trading empire.

With such sources of income, Orcadian earls could take their place in affairs on a larger scale, and could for instance, as in the case of Earl Thorfinn the Mighty in the mid-11th century, hold substantial territory in Scotland and even Ireland. Up to a point, a strong earl in Orkney was a benefit to Norway, as the sea-lanes could be kept open efficiently and the provisioning and repair of ships carried on smoothly. On the other hand, too powerful a ruler in such a sensitive place could become dangerous. So the paradox emerged whereby an earl as powerful as Thorfinn found himself saddled on home territory with a joint-earl—his nephew Rognvald—promoted by King Olaf of Norway.

The system worked reasonably well for a time, but eventually broke down in strife, and Rognvald was killed. Thorfinn had effectively cut a tripwire, but managed to make his peace with the king of Norway; he had at least restored the peace in Orkney which was essential to Norwegian trade operations.

The Norwegian ruler by this time was Magnus the Good, who had succeeded his father Olaf, after some years of Danish rule under Cnut. Olaf, killed at the battle of Stiklestad, was made a saint by the Norwegians, and the

founding of a church dedicated to him in Kirkwall is ascribed to Rognvald, who is recorded as taking up residence there a short time before his death.

Thorfinn, on the other hand, seems to have had the West Mainland for his base; when in subsequent years he appointed a bishop in Orkney, and built a cathedral church, the site was in Birsay. Thus in Orkney, as elsewhere, churches were established in centres of political power.

The existence of joint-earls also opened up opportunities for other states besides Norway to get involved in the affairs of Orkney, as part of an overall political strategy in the north.

Fragments of evidence in the historical record thus give clues to undercurrents of power. The records of the appointment of bishops, deftly marshalled in this present book by Professor Ian Cowan, show that there were often interests from much further afield to be taken into account—from York, Hamburg, and from Rome itself.

Despite these undercurrents, the pattern of joint-earls continued, through Thorfinn's sons Paul and Erlend. It went on into the next generation, with Paul's son Hákon, and Erlend's son Magnus; but the clash of interests built up into conflict.

A meeting of the two earls was held in Egilsay at Easter time, in order to resolve matters. It succeeded in doing so, but the price was Magnus's life. The way that Magnus went to his death was remarkable. He was an extremely popular figure in Orkney, and his killing could have led to violent retribution and civil war. Instead he went out of his way to prevent this, forgiving his killers, and literally giving his life for the peace of Orkney.

The example shown by Magnus shone like a beacon light; and it did succeed, with peace and stability prevailing under Hákon's sole rule. But stories began to grow that a real heavenly light was seen over Magnus's grave, in the Christ Church in Birsay which his grandfather Earl Thorfinn had built.

The year of Magnus' death is debatable: it has been put between 1115 and 1117. After Hákon's own death, his sons by separate mothers—Paul and Harald—fell out and divided the earldom between them. Harald's mother came from Caithness, and a dark note enters the story with her and her family. They apparently tried to murder Paul, but ended up

killing Harald by mistake.

That left Paul to rule alone, and although he is described as well-liked and able, a threat began to build up on two fronts. One challenge came from Harald's Caithness kinsfolk; the other from Norway, where the sister of the murdered earl Magnus had lived after marrying a Norwegian landholder, Kol Kalason. Their son, Kali, had a claim on the earldom of Orkney, and decided to pursue it, with the support of first King Sigurd of Norway, and then his successor, King Harald Gilli.

The *Orkneyinga saga* describes how Kali made two attempts to win the earldom, failing the first time, but the second time following his father's advice to the letter and succeeding. There is layer after layer of intrigue under the surface, and a darker strand keeps coming though in the kind of allies that he had to use—the kinsfolk of the dead Earl Harald, and the violent Svein Asleifsson, who kidnapped Earl Paul and carried him away to a captivity in mainland Scotland from which he never returned.

One of the keys to Kali's success was Bishop William, and a memorable pledge: to build a cathedral in Kirkwall in memory of Magnus if successful in his quest. Stories of miracles at Magnus's grave in Birsay had been allowed to flourish after a visit made by the bishop to Norway; he subsequently had Magnus declared a saint and his body taken to Kirkwall, presumably to the church of St Olaf that had built by Rognvald Brusason.

Rognvald's very name had in fact been taken by Kali right at the start of his plans to win the earldom. He was thus weaving around himself some powerful images: a connection with the much-loved Rognvald who had lived in Kirkwall, to add to the family connection with the dead Earl Magnus.

Once in power, Rognvald continued to make use of his father's guidance, with Kol taking on the great task of supervising the construction of the planned cathedral. There were sources of information to be tapped in, for instance, Scotland, where under David I (1124-53) Norman ideas of building up a strong administrative system for Church and State had been introduced.

There is a timescale which fits the movement of skilled master masons from Durham northwards through Scotland

to Orkney by way of Dunfermline Abbey, founded by
David around 1128.[13] The architectural connections have
been analysed over the years. For example, in both St
Magnus and Durham, some of the capitals on top of the
pillars—the stones which form the base for the arches
above—have a characteristic shape, octagonal with scalloped
undersides. The small round arches and columns built into
the wall—the wall arcading—has at both Kirkwall and
Durham an intersecting pattern whereby each arch crosses
over its neighbour to terminate on the next-but-one shaft.[14]

 To bear the initial cost of the project, Rognvald
clearly had to have a lot of money; he subsequently did need
to raise more by selling the Orkney landholders the odal
rights of their estates. If Orkney was to be worth this kind
of money to him, it must have been able to generate
considerable income. There are signs that it did, with for
instance the rapid development of the town of Kirkwall.
And it may well be that this development was also part of
Rognvald's overall plan.

 From early life, he had been involved in trading, sailing
at the age of fifteen with merchants to the English town of
Grimsby, and then going over several years on voyages from
the great Norwegian port of Bergen. It was an exciting time
for international trade, under the pattern of stability built up
by various rulers. All over Europe there was a growth of
towns, often specially built for trading purposes. Roman
cities had been mainly for administration, but the new towns
were market-places where an international community of
merchants could mix freely.

 Church and market-place were together in the new
towns, as part of the overall pattern of order and stability. It
is not hard to see how ideas could have germinated from
Rognvald's travels, developed gradually in discussion with his
father Kol. The attraction to Rognvald's supporters in
Orkney and Norway could thus have been the overall vision
that he promised to turn into practice, of a major new
international trading-centre at Kirkwall, with harbour,
market-place and cathedral. The time was right, with the
growth of sea trade in the north and the development of
bigger types of ships, and the role of Orkney under
Rognvald has been compared with that of Venice in the
Mediterranean.

 There were cultural parallels, too. It was in general a

kind of intellectual spring all over Europe; the new freedom to travel was enabling people to go on pilgrimages, or to study at the new universities. Rognvald's energy and ability, which in his youth had gone into adventure at sea and on shore, and later into the quest to win the earldom, seems to have been given full expression in bringing to Orkney the new ideas of the time.

Many benefits to a community flowed from the establishment of a cathedral. Those who would serve there needed to be trained to the highest standards. There would have been a music school, and it has been suggested that Rognvald himself may have founded it, and that the Cathedral was the reason for the establishment of the grammar school in the town. Rognvald was in his own right a poet whose verses are preserved in the *Orkneyinga saga*. He brought in poets from Iceland, and composed the long poem *Háttalykill* with one of them. The *Hymn to St Magnus*, preserved in Uppsala, has been attributed to this time in Orkney, of the great cultural flowering of the 12th-century Renaissance.[15]

As a focus for intellectual activity, the Cathedral established a tradition which was followed in later centuries, as Dr Duncan Shaw's chapter here on two great bishops of the 16th century illustrates. This tradition of clarity of thought is brought, further on in the book, into the present day by the Rev. Ronald Ferguson and by the Very Rev. Prof. Robert Craig, each tackling the great issues of our time and building up a strong rational base of principles from which to chart a course of action. Thus the pattern of the Church setting the foundation for the order of society continues into our own time, as it did in the vision of Constantine, of Charlemagne, of the Norman dukes, and of Rognvald.

And, of course, above and beyond all that is the spiritual impact of the Cathedral. The growth of the medieval town meant a greater general bustle and activity in the affairs of this world; the medieval cathedrals gave a corresponding counterweight to matters of the spirit. From a busy market-place, and the often intense day-to-day matters of island life, a door only a few short steps away leads to a still place in a turning world, where the solid pillars stand firm on the rock they are founded on, and where the human eye and the human spirit can rise upwards through the

harmony of the building.

There is something too, in the stone of the Cathedral, which has retained its character through the process of cutting and shaping, and retains within it the warmth and strength of the natural world, rather than the neutrality of building blocks shaped to human design. The writer Eric Linklater observed how the red stone of the exterior makes it seem to rise up like a great sea-cliff at the west front. Within the Cathedral itself, the stonework was in the early days covered by thin plaster and richly painted with images of angels and saints. Today in its warm natural form, it seems to reach to something deep, beyond where intellect and architecture and mathematical design can take us: what the philosopher Henri Bergson called "that more vast something out of which our understanding is cut, and from which it has detached itself."

Rognvald himself had one more peak to his life, after the heady days of the founding of the Cathedral and the regeneration of the Earldom. He went on a pilgrimage to Jerusalem, and for a time was able to free himself from the cares of administration in Orkney and join in the great adventure of travel once again. His journey through the Mediterranean was as full of incident as that of the legendary one of Odysseus before him, with the storming of a castle, raids on Moorish territory and a Saracen ship, and an encounter with a beautiful princess in the town of Narbonne. But as for Odysseus, there was a bleak homecoming, with matters badly wrong in Orkney.

In Rognvald's absence, the young Harald Maddadsson, a grandson of Hákon whom he had accepted as joint-earl, had failed to hold the islands on their behalf. There was external pressure from King Eystein of Norway, who had asserted his authority over the earldom; and a threat from another grandson of Hákon, Erlend Haraldsson. To reassert his authority, Rognvald had to use all his ability, thinking and moving fast on land and sea, switching tactics and shifting alliances under pressure from several quarters. He won the earldom back again, and continued to share it with Harald Maddadsson, for what turned out to be only a few brief years. Rognvald was killed in Caithness in what seems to have been an unnecessary encounter with an outlawed man. Perhaps he had developed too great a liking for action rather

than quick thinking; or perhaps in the aftermath of the great days that would never come again, he had lost interest and become careless.

Whatever its ultimate cause, Rognvald's death left power in the hands of Harald, who ruled as sole earl through until the beginning of the next century. For a while the Cathedral work seems to have run down, but about thirty years after Rognvald's death, building operations were energetically revived, with the appointment in 1188 of Bjarni Kolbeinsson as Bishop of Orkney.

Looking at the building in its shape of a cross, the shorter eastern part, known as the *choir* or *chancel,* with a semi-circular apse at its far end, is where the work is believed to have started, and to have been completed before Rognvald went on his pilgrimage to Jerusalem. This in a way is the heart of the building, with the rich colour of red and white stones in alternating courses and arch rings, described overall as "the finest Romanesque work north of Durham".[16] There was obvious importance in getting this part of the Cathedral finished as soon as possible, in order to incorporate the remains of St Magnus.

Work would have continued through the two arms of the cross—the *transepts*—and on into the nave. The work of the great second phase under Bjarni Kolbeinsson was to complete the transepts, to raise up the central section of the nave, and to begin the west front with the three doorways that now look out onto the main street of Kirkwall. At the same time, the original design was modified to provide enlarged chapels in the transepts, along with an extended choir.

The architectural style of the time was changing. Among the features of the new Gothic style which was emerging was the graceful pointed arch, stronger than the rounded Romanesque arch of the Normans. (The name 'Gothic' was given to this style much later by architects who wanted to dismiss it as barbarian, and return to the Roman mode.) The appearance of the pointed arch amongst otherwise Norman features marks a short Transitional period before the full Gothic architecture developed. In the Cathedral, the Transitional style can be seen in the windows of the transepts and the doorways of the west front. It can also be seen in another area that was rebuilt at the time, the *crossing,* where four great piers carry the weight of the

central tower through pointed arches that rise above them.

The work of this time appears to show similarities in style to that at Nidaros Cathedral in Trondheim in Norway, to the extent that masons from Nidaros may have been brought over.[17] This would be in keeping with a strengthening of Norwegian influence in Orkney marked by the incorporation of the diocese into the See of Trondheim in 1153. Since Nidaros was dedicated to the Norwegian king and national saint, Olaf, to whom the original Rognvald may have dedicated a church in Kirkwall, there is something appropriate in this later link.

At the end of this second phase there was still some work that had to wait for a later century to be finished, including the completion of the upper part of the west front and the section of the nave adjoining it, but Bishop Bjarni had taken an enormous step towards completing Rognvald's vision. He had also given Rognvald himself recognition by getting him canonised in 1192 and his remains brought into the Cathedral. And he may have done even more than that.

The *Orkneyinga saga* is in many ways the story of Rognvald, the background to the work he did, and a depiction of the things that he most enjoyed. Fully two-thirds of the saga is given to the story from Magnus through to Rognvald, and the earlier part sets the context for what follows. Pointers to Bishop Bjarni's involvement with the saga in some way have been noted on various occasions. He was himself a poet of distinction, the author of the *Lay of the Jomsvikings* where the story of old battles was inlaid with a medieval refrain of courtly love; he had numerous contacts with the intellectual community in Iceland, where the *Orkneyinga saga* was written; and Bjarni's own genealogy is outlined in the saga, one of the only two families outside the earls to be mentioned like this.

Furthermore, Bjarni grew up in Wyre, not only next to Egilsay where Magnus was killed, but also right by Svein Asleifsson's island of Gairsay. Bjarni's father Kolbein had fostered one of Svein's sons; another son married Bjarni's sister. One of the strange features of the saga is the way it treats Svein, not shrinking back from setting out his misdeeds, but yet getting very close to his way of looking at the world.

To write such a saga, about people not long dead, and issues and heirs that were very much alive, was to make a

series of moral and legal judgments, to stand for all time.
The good and the bad had to be gathered in and told, and
the meaning of it all unravelled and laid out clearly and
fairly, with the search for truth the guiding principle. The
saga does read as if the writer was concerned to deal fairly
with every person in it, even to heal the old sores of conflict
rather than stir them up anew. Despite the emphasis on
Magnus's saintliness, there is mention of Hákon's tears when
he faces Magnus's mother after the killing; and the verdict on
Hákon's rule is one of peace, just laws, and good
administration.

The answer to the question of authorship may never be
found; only the continuation of patient scholarship over
many years will build up the basis for deductions.[18] But
Bjarni himself was through his mother a distant relative of
the earls, and may well as a young man have met Rognvald.
He set his own ability to the task of completing Rognvald's
work and putting the dead earl's bones to rest into the
cathedral that he had founded; and it would be a fitting
complement to that work to think that through the saga he
put the great events leading up to it into a context of deeper
understanding, giving historical substance to Magnus and
what he died for, and building in to the picture of Rognvald
all the things he liked best, so that the earl has his own kind
of immortality, setting out from Kirkwall harbour in a
summer breeze, bound for the Mediterranean and Narbonne.

And a final notable aspect of the Cathedral is the way in
which it has inspired the actions of the generations after
Bjarni. The warmth of the building makes it indeed, as in
Storer Clouston's words quoted earlier, "something alive",
seeming to carry something of the personalities of Rognvald
and Magnus in it, and inspiring a similar kind of affection.
Whenever its fabric is in danger, someone come to its aid—to
prevent destruction or to stimulate restoration. When the
need on other occasions is just to stand firm and hold on
when all around seems to be slipping away, there are people
of the dedication of the 19th-century minister the Rev.
William Logie, described in a chapter here by his present-day
successor. And for each of these crises and people who
emerge above the current of history, there are a myriad of
individuals who have done something that, however large or
small, required of them to give their best, making or giving,

or fetching and carrying, in which their piece of work fitted into the overall pattern like one of the many pieces of stained glass in a window. The Cathedral is indeed a light shining in the north: this book contains some selected pieces of bright glass gathered through past centuries, to let the light shine on into those ahead.

Note on orthography

For Old Norse names, the conventional form rather than the original is used throughout in almost every case. The exception is in the name Hákon, where the pronunciation of the 'a' sound as in the word 'hall' is often confused by other spellings.

INTRODUCTION TO
THE CONFERENCE
Edwin R. Eunson

It gives me great pleasure to extend, on behalf of the
Anniversary Committee and Orkney Islands Council, the
representatives of the owners of this Cathedral, the people of
Orkney—a very warm welcome to all the speakers and
participants in this Easter Conference.

The celebration of the 850th anniversary of the founding
of St Magnus Cathedral began on St Magnus Day, 16th April,
with the switch-on of the new floodlighting system, thus
setting the theme of 'light' which we shall be following
throughout the season. It is fitting that the first of the many
events which will commemorate the anniversary should be
this conference, in which we will study together, with the
help of the distinguished scholars who will be taking part, the
Given Light of the life and worship of St Magnus Cathedral
through the centuries.

Much will be said in the weeks and months to come
about different aspects of the building—its architectural
significance, the part it played in the culture of the ages during
which it has stood, its part in the history of the islands and
their relationship with Norway and Scotland, and its
importance as a piece of history which has come down to our
day.

It is right that this should be so, but we must remember
that its supreme importance is in the purpose for which it was
founded and for which in the providence of God it has
continued through the centuries to the present day, a place for
the worship of God.

The Cathedral has been in danger on several occasions
during its history. When the Earl of Caithness (who had no
reason to like the Orcadians who had defeated and killed his
ancestor at the battle of Summerdale), put down the rebellion
of the Stewart earls in 1614 and demolished Kirkwall Castle,
he intended the Cathedral for the same fate, from which it

was delivered by the intervention of Bishop Law. Less spectacular but no less dangerous was the fate which threatened it in the middle of last century, when the building was reduced by lack of maintenance into an almost derelict state and there was a move to abandon it as a place of worship and to build a new church. On this occasion it was rescued by a government department which carried out restoration. Finally, about fifteen or sixteen years ago, a survey shocked all who loved the Cathedral with the information that the west gable was cracked and was in danger of collapsing onto the Kirk Green.

This startling news led to the launching of the 'Save St Magnus Cathedral Appeal' which, with the support of many friends, both in the islands and throughout the world, carried out restoration work and made the fabric safe. This initiative led to the continuing efforts to enhance and improve the building and its furnishings, to perpetuate the wish of its founder, St Rognvald, that it should be "the wonder and the glory of all the North."

A further step in this direction will be the unveiling of the new west window, again with the theme of Light, by Her Majesty the Queen in August; followed by Her Majesty the Queen Mother, Patron of the Society of Friends of St Magnus, accepting the gift of a tapestry from our twin county of Hordaland, which will be handed over by His Majesty King Olav V of Norway.

Chairman of the Conference, distinguished guests, ladies and gentlemen, may I greatly daring, borrow the words of the Queen when opening a new session of Parliament, and pray that the blessing of Almighty God may rest on your deliberations.

THE MEDIEVAL BISHOPS OF ST MAGNUS

Ian B. Cowan

The origin of the Bishopric of Orkney is obscure, but its development certainly lies in the consolidation of Norwegian influence in Orkney and in Shetland. This factor was, however, complicated in the early 11th century by Scandinavian domination of England, which for a time was ruled by the Danish king Cnut, the Canute of English history (1014-35). For a spell, his dominions included Norway as well.

The first known bishop in Orkney, Henry, who appears on record before 1035, was apparently an Englishman. He was also keeper of King Cnut's treasure in England, and may indeed have been appointed bishop in Orkney while holding that office.

Henry was what is termed a missionary bishop, without a fixed cathedral of his own in Orkney. He seems to have recognised the metropolitan authority of the Archbishop of York, but may ultimately have been active in Iceland and consequently be the same Bishop Henry who was appointed by the king of Denmark to the See of Lund, c. 1060-61. If indeed this is the case, it may indicate the increasing power of the Danish king in the far north at this time.[1]

The appointment of a missionary bishop to an area was the first stage in the process of Christian conversion and incorporation into the sphere of authority of a Christian king. Despite the interest of Cnut in the work of Bishop Henry, the main movement of Christianity into the Norse lands was to come from the Holy Roman Empire, through the archbishops of Hamburg, based for safety and convenience in Bremen instead. Indeed, it seems to have been the Archbishop of Hamburg/Bremen who appointed the next bishops in Orkney after Henry.

The order of the succession of these Orkney bishops is debatable. Nevertheless, the evidence would suggest that

Henry's successor was a Scot or an Irishman named John, who was approved by the archbishop as one of the English or Scots said to have been normally appointed to the See.[2]

These men still came in the category of missionary bishop, without a fixed See, but with the establishment of the first cathedral in Orkney, at Birsay, by Earl Thorfinn between 1048 and 1055, a consecrated bishop was appointed; and he came from outwith the British Isles.[3]

It is traditionally accepted that this first consecrated bishop of Orkney was Thurolf, appointed c. 1050 by the Archbishop of Bremen on the specific authority of the Pope. Thurolf's successors were apparently John and then Adalbert, although it is possible that this latter may have in fact preceded Thurolf.[4] Not until 1073 does the succession of bishops become more clearly identifiable, for in that year Radulf was nominated as bishop by Paul, son of Thorfinn and joint-earl of Orkney, who for some reason that we do not understand sent his nominee for consecration to the Archbishop of York.[5]

It has been suggested that one reason for Paul's choice of York in this matter was the fact that the recently-appointed Archbishop of Bremen did not possess the pallium of metropolitan authority, a difficulty which persisted between 1101 and 1123. Whatever the reason, the decision of the Earl allowed the flourishing of York's aspirations to control the northern diocese.[6] This was apparent when Radulf died, for immediate action was then taken at York to consecrate Roger, a monk of Whitby, as his successor.

At the time, the See of York was in fact vacant, and the commendation of Roger to the earl of Orkney (by this time Hákon), came from the Archbishop of Canterbury instead. It is, however, doubtful if Roger ever left England to take up residence in the islands, as he is known to have been available in York for a proposed consecration of a Bishop of St Andrews.[7]

This tension over the church administration in Orkney, between Hamburg/Bremen on the one hand and York on the other, was mirrored in a similar conflict between Scottish bishops and the archbishops of York, who were pressing a claim for mainland Scotland to come under their metropolitan authority. The tension in Orkney was intensified by the appointment as Roger's successor of another man with a York connection.

This man, Radulf, had in fact been appointed by some Orcadians at York, and consecrated there by the Archbishop, Thomas, with obedience to the See of York, but he failed to obtain possession in Orkney. Efforts that were made on his behalf were unavailing. We know, for instance, that Thurstan, elect of York, took Radulf with him to his own consecration by Pope Calixtus II at Rheims on 19 October 1119, thereby misleading the Pope into believing that Radulf had been canonically elected and consecrated. But the Papal recommendation to Kings Eystein and Sigurd of Norway that Radulf should be accepted as bishop in Orkney went unheeded.[8]

If no rival candidate at this time is immediately evident, one was apparently on the horizon. When Pope Honorius II raised the subject again with King Sigurd in a letter on 9 December 1128, he mentioned another bishop who had apparently been intruded. The request for the removal of the alleged usurper went unheeded, for the Papal nominee from York was apparently not only unacceptable to the people and clergy of Orkney, but more significantly to 'the prince of the land' (whether King or Earl is not clear). In consequence, Radulf never obtained his northern prize, but for a time continued to serve as an auxiliary to both the Archbishop of York and the Bishop of Durham. More dramatically, he was present with the English army at the Battle of the Standard in 1136, but after the defeat there of the Scots moved further south, and is documented as being present in the dioceses of Winchester and Lincoln before disappearing from record in 1147.[9]

The man who despite all these various claims from York was in actual possession of the bishopric of Orkney during this period of conflict was Bishop William, who apparently held the see for 66 years after his election in c. 1102. This election took place during the period when Sigurd (later 'the Crusader' and king of Norway, 1103-1130) was ruler in Orkney, as king under his father, King Magnus Barelegs. William's appointment as bishop in Orkney clearly reflects a rejection of York's metropolitan authority in favour of that of Lund, which from 1103-4 had replaced Bremen as the metropolitan see for the Norse dominions. If the date of William's election is correct—and this has been questioned—he must have been bishop at the time of the death of St Magnus on 16 April 1117; and William's

veneration for the saint would explain his interest in removing his own cathedral from Birsay to Kirkwall in c. 1137.[10]

By that date, the nephew of St Magnus, Earl Rognvald-Kali, was actively promoting the construction of the new church, which he had promised to build more magnificently than any other in these lands. If this aim was not achieved immediately, some parts of the structure was certainly in existence by 1155. The ultimate objective nevertheless remains uncertain, for in design this building included two doors in the south aisle which, it has been argued, were "intended to communicate with the cloisters of a projected monastery."[11]

If this is so, it may be that a Benedictine community on the Durham model (the model which was being followed for the building) was intended, and the plan of the building would then have been altered when a community of secular clergy emerged. This transition was also marked by a transference of the bishopric in 1153 to the authority of the metropolitan see of Trondheim. Either for this reason, or more probably because of the move to Kirkwall, William was to be remembered as first Bishop of Orkney.[12]

Thereafter, he and his successors, of whose personal lives little is known, remained firmly within the Norwegian orbit. One of their number, Biarne or Bjarni Kolbeinsson 'skald' (1188-1223) was apparently a poet. Another of William's successors suffered long years of paralysis, while an unnamed elect of Orkney was captured in a ship of war by some English pirates and killed at some time before 15 September 1227.[13] If such bishops and their successors were ostensibly selected locally by a chapter, who by the 13th century may have been equated with canons of the cathedral, it is more than likely that the chapter's freedom of choice in this process was purely nominal; the bishop-elect would be imposed by others outwith this framework.

Who the decisive figure would be in such appointments is uncertain. The kings of Norway and the earls of Orkney both had powerful vested interests; nevertheless, Dolphinn, who was bishop between 1286 and 1309, was apparently chosen by Andrew, Bishop of Oslo.[14] However, in all probability it was the voice of the earls that became increasingly powerful in the election of a bishop.

Such lay influence was not unique to Orkney. In order

to combat this kind of practice, successive Popes from the end of the 13th century claimed that the right to select a bishop lay exclusively with the Holy See. Papal provision, as this process was named, soon came to be the only canonical means of appointing a bishop. Such claims from the Church were—not unnaturally—resisted by those who had previously asserted lay influence, and struggles between rival candidates, one supported by the Pope and another who was the local choice, were not unknown. Popes were, however, often more interested in a tax, known as *the common services,* which complemented their claim to provide. In consequence, the interests of the Papacy frequently turned out to harmonise with those of the locality.[15]

Evidence for the introduction of this system of Papal provision appears somewhat later in Orkney than elsewhere in Scotland. It is not until the late 14th century that the first indications of the procedure are available.[16] By this period, however, ecclesiastical allegiances had been further complicated by a schism in the ranks of the Papacy which arose in consequence of the residence of 14th-century Popes at Avignon. In 1377 the French Pope was to return, accompanied by his pet lion, to Rome. Neither liked the change of venue; the lion died, and so too in 1378 did his master, on the eve of his departure back to Avignon.

At this point, in terror for their lives, the largely French cardinals were forced by the Roman mob to elect an Italian Pope. They thereafter, however, withdrew to Fondi where they elected as Pope one of their number, Robert of Geneva, who took the title of Clement VII. Understandably the Italian Pope Urban VI refused to resign; the Great Schism had commenced.[17]

In their obedience to the Papacy, the nations of Europe were equally divided. Scotland, for its part, immediately proclaimed its support for the French and Clement VII, who had returned to Avignon. The King of Norway, however, continued in his allegiance to the Roman Popes. The Orkney bishop of the time, William, followed suit. Nonetheless, the proximity of the Orkney diocese to Scotland, along with increasing Scottish influence in its affairs, placed the Orcadian bishops in a medial position between the two contending forces.

Bishop William was killed in Orkney in 1382 or 1383, and in the controversies which followed, Rome rather than

Avignon seems to have had the better of things.[18] The French Pope Clement VII did provide a bishop to the see on 27 January 1384 in the person of Robert de Sinclair (Sancto Claro). Sinclair had been described previously, on 28 November 1383, as bishop-elect, but this appears to savour of wishful thinking, as his mandate on 30 January 1384 for consecration by any catholic bishop proved to be.[19] Although destined to become bishop of Dunkeld, he never obtained the bishopric of Orkney, and the see fell to John, rector of Fetlar in Shetland; he was elected by the Cathedral chapter following Bishop William's death, and then subsequently provided by the Roman Pope, Urban VI.

Although John was thereafter consecrated at the Papal court in Rome, his provision was apparently still in dispute when the Pope died on 15 October 1389; the problem evidently arose from his absence from Orkney.[20] Diocesan duties, if they were performed at all, appear to have become the responsibility of Henry, Bishop of Greenland, who was certainly in Orkney on 27 January 1391. Three years later this situation was to be regularised by exchange; Henry became Bishop of Orkney on 9 March 1394, while John became Bishop of Greenland, a see from which he equally remained an absentee.[21]

Thereafter Henry's position as Bishop of Orkney remained unchallenged. But on his death (at some time before 21 August 1396), the struggle for supremacy in Orkney between the rival Popes was again resumed. The Roman Pope, Boniface IX, provided on 2 August 1396 a monk of Colchester, John Pak, who was consecrated as bishop at some time before 13 September 1397. This John Pak was a much-travelled monk who is recorded, for instance, as being in Sweden on 23 June 1397, and he apparently remained in possession of the see until his death which was some time before 19 August 1488.[22] There was, however, opposition to his appointment in Orkney, with support forthcoming for successive rival candidates supported by the Avignon Popes.[23]

Clement VII, who died in 1394, was succeeded in Avignon by Benedict XIII, who was ultimately forced by withdrawal of French support to move to Peniscola in Spain. From there, however, he continued to maintain the schism, and Scotland remained unswervingly loyal to him. Pope Benedict provided Alexander Vaus to the see of Orkney

shortly before 7 November 1407, and received support from Scotland for him.[24]

It is true that efforts from 12 November 1408 to have this Alexander Vaus consecrated in Orkney appear to have been unavailing. But it is significant that when he was translated on 4 May 1414 to the bishopric of Caithness, with retention of the bishopric of Orkney, the Papal letter was addressed to the King of Scots rather than the King of Norway—demonstrating that in Orcadian terms an appeal was being made to a growing Scottish presence within the islands.[25] Nevertheless, when Benedict next attempted to impose a candidate of his own choosing upon the bishopric of Orkney, through his provision by April 1415 of William Stephenson, the mandate was on this occasion addressed to the King of Norway.

If consecration at the Papal court did follow the provision of this William Stephenson, it had no immediate effect. Indeed, even the end of the Schism in 1418 brought no consolation to Stephenson, for although his provision to Orkney was then endorsed by Pope Martin V, whose election had again unified Christendom, the candidature remained ineffectual.[26]

In all these manoeuvres, Pope Martin appears to have acted in ignorance, for he himself had nominally provided another successor in the see to John Pak on 11 August 1418 in the person of Thomas de Tulloch. The ensuing struggle between Stephenson and Tulloch seems to have been short-lived, and may perhaps have been terminated by some division of the fruits between the rivals, Tulloch succeeding by 30 October 1419. He was consecrated by 10 June 1420, at which time he is reported as acting in Denmark with other bishops subject to Trondheim. The Nordic association had triumphed, and so too had Tulloch, who remained bishop until his resignation on or before 11 December 1461.[27]

Bishop Thomas's lengthy episcopate was characterised by his allegiance to the Norwegian cause, but family loyalty was also to the forefront; his successor, William Tulloch, was obviously a relation who was provided upon Thomas's resignation. William too demonstrated loyalty to the Scandinavian association, and following upon his consecration he swore fealty to the 'King of Denmark and Norway' at Copenhagen on 21 July 1462. His inclinations, however, also lay in other directions, for when he ended his

episcopate after fifteen years of faithful service, it was consequent upon his appointment to the bishopric of Moray on 12 February, 1477.[28]

By this date, a more significant change in the relationship between Scotland and Orkney had already taken place, for in 1468/9 the political allegiance of the islands had been transferred by the pledging of the earldom lands by the King of Norway as surety for his daughter Margaret's dowry, following upon her marriage to James III, King of Scots. This arrangement, which may have been intended as a temporary expedient, nevertheless paved the way for the transference of metropolitan authority from Trondheim to the newly erected archiepiscopal see of St Andrews on 17 August 1472.[29]

If the change of authority was not immediately reflected in the allegiance of the bishops—for the provenance and loyalties of William Tulloch's successor, Andrew Painter or Pictoris, are somewhat doubtful—Scottish nominees were in control by 8 December 1498 when Edward Stewart was recommended by the Crown as co-adjutor and successor to Bishop Painter.[30]

This recommendation was in line with an agreement, the so-called Indult of 1487, between James III and Pope Innocent VIII, which meant in effect that the Crown would nominate holders of major benefices, including bishoprics.[31] If, in consequence, many Scottish sees received unsuitable nominees, Orkney seems to have been treated fairly in this respect, as most of the early 16th century bishops appear to have been fitted for their position. Edward Stewart (who continued in office until 1524/5), his short-lived successor John Benston, and Robert Maxwell (1526-41) all appear to have fulfilled their duties, even though the organisation of the see and that of its Cathedral was passing through difficult times.[32] The rectifying of these faults and the reorganisation of the chapter was, however, to fall to Maxwell's successor, Bishop Robert Reid, who succeeded from the position of Abbot of Kinloss on the nomination of James V on 5 April 1541. If Bishop Reid's appointment was somewhat irregular in so far as he retained his abbacy as commendator, the reforming mark he made at Kinloss was subsequently transferred to his new charge.[33]

Reid's achievement in this respect can, however, only be assessed in terms of the previous organisation of the diocese

and in relation to the bishop's authority therein. That remit was considerable, as a bishop possessed jurisdiction of both a spiritual and a temporal nature.

In terms of his temporality, a bishop possessed lands, the administration of which would be placed in the hands of his *baillies*. This delegation of function was paralleled in the field of his spiritual authority. First and foremost a bishop was responsible for the welfare of his flock and that of his fellow-priests who exercised the cure of souls. This function was devolved in various ways, mainly to an *archdeacon*, the eye and ear of the bishop, who could censure, but not deprive, members of the clergy.

In a bishop's discharge of his spiritual duties, his cathedral and the clergy who served in it were of prime importance. Such clergy, known as *canons*, varied in number from cathedral to cathedral, and were each supported by revenues. These revenues were normally derived from the *teinds* (tithes) of annexed or appropriated parish churches, which constituted their livings or *prebends*. The canons meeting together constituted the *chapter* of the cathedral. Their duties extended to their participation in the election of a new bishop and the provision of services within their cathedral church. If their voice in the choice of a bishop tended to be nominal, so too was their attendance at the services of the cathedral, for here too deputisation by clergy known as *vicars choral* was normal.

It is questionable how far the clergy of Kirkwall Cathedral conformed to this general pattern, as many details are not known. The first mention of a chapter in Orkney occurs at the election of Bishop Henry in 1247, but there is no record of who participated in his elevation to the episcopate.[34]

In general, early chapters often consisted of representative members of the diocesan clergy, presided over by the archdeacon. One unusual aspect of the early meetings of the Kirkwall chapter is that they seem to have been presided over by the Shetland archdeacon of the overall Orkney diocese. (Due to the geographical intricacies of the diocese of Orkney, there was a division of responsibility between two archdeacons—one for Orkney, and another for Shetland.) It has been suggested that this role of the Shetland archdeacon may originate with the Shetland archdeaconry being older than that of Orkney. Archdeacons of Shetland appear from

1215, but the presence of one in Orkney is first noted in 1309.[35] Prior to this, at the time when a community of canons was emerging to constitute the cathedral chapter of the cathedral church of St Magnus, the only archdeacon may have been the Shetland one, who would thus have been made their head.[36]

The practice of the Shetland archdeacon presiding over the chapter was certainly a standard one, as no separate dignitary has been identified as head of the college of canons before the reconstitution of the chapter in 1544. Moreover, at that point the then archdeacon of Shetland, as provost of the Cathedral, became head of the newly-created chapter; this has led to the further surmise that the new provostry of the Cathedral was conceived as a splitting off from the archdeaconry of Shetland, with the appropriate revenues, of that part of the archdeacon's responsibilities which had embraced the duty of presiding in chapter.[37]

Devolution of episcopal duties was not restricted to the archdeacons. Authority was also delegated to *deans of Christianity*. Many Scottish dioceses possessed such figures, who in England and elsewhere were known as rural deans. However, in Orkney, deans appear only in the 16th century, and act for the diocese as a whole; they nevertheless antedate the reforms of 1544.

In most other dioceses, the duty of presiding over the chapter was eventually entrusted to a *dean* (not to be confused with the dean of Christianity). The earlier format of the archdeacon presiding was gradually replaced by a more formal structure into which the archdeacon was engrossed, but no longer as head. The dean, or *provost* as he was known in Orkney, in this role was assisted by other dignitaries: the *chanter* who was responsible for services; the *chancellor* who was in charge of the charter chest and the writing house; and a *treasurer* who oversaw the cathedral's financial affairs. At Kirkwall, however, no such officers are known to exist before the reconstruction of the chapter in 1544, and the possibility is thus strengthened that until then the archdeacon—and presumably still that of Shetland—continued as head of the cathedral chapter.

The authority over the clergy possessed by the archdeacons and the dean of Orkney was partly administrative and partly legal; but the bishop also possessed his own court with jurisdiction over both clergy and laity. Such

powers not only related to cases of legitimacy and marriage, but extended to all causes in which an oath or contract was involved. Business deals, and land and mercantile trans- actions, could thus be adjudicated; they were normally, however, dealt with not by the bishop, but by his deputy known as his *official*. If in Orkney evidence for such a judge is no earlier than 1461, the system is clearly discernible in the 16th century, and had indeed been strengthened by the addition of a commissary of Orkney in 1504 and an official of Shetland, who first appears in 1545.[38]

Going back for a moment to the first mention of a chapter in Kirkwall, at the election of Bishop Henry in 1247, the bishop is recorded as being himself a canon, so the chapter itself must antedate this event. And from this time onwards, a group of canons can certainly be identified in the various records: by 1266, as the canons of St Magnus, they had a sufficiently corporate character to be appointed in the Treaty of Perth to receive annual payments for the king of Norway from the king of Scots.[39]

The practice also developed at St Magnus Cathedral, as elsewhere, of endowing certain canons with the teinds from particular parish churches, giving them their livings or prebends; although it is not until 1327/8 that evidence for this is forthcoming. In a tax roll of this date, the first recorded Orcadian constitution indicates that one of the prebends was held by an individual (Sir Richard), but other endowments are specifically described as the prebends of Stronsay, Sandwick, and Holy Cross of 'Be'. (If the location of the latter poses something of a problem, the fact that the church of Sanday was dedicated to the Holy Cross and also situated near the Bea Loch and Bea Ness suggests a likely answer.) Thus from these references a chapter with at least four prebends appears to have been established by the early 14th century.[40]

Thereafter, the process of erecting prebends would appear to have continued with as many as twelve appearing in the course of the 15th century: Birsay and Harray; Burray and South Ronaldsay; Hoy; Kirkwall St Ola; Orphir; Sanday Cross; Sanday Lady; Sanday St Colmes; Stronsay Lady; Stronsay St Nicholas; Tingwall, Whiteness and Weisdale; and Westray Cross.[41]

Whether all these prebends existed at the same time is questionable, and clearly some fell into decay. In all

probability, however, prebends were transient creations held on a personal basis rather than in terms of any established constitution, although the number of canons may have been traditional. In totality this may well have been as few as six, for in 1544 it is recorded "that only six canons and as many chaplains . . . were known hitherto to be erected within the same . . . and what pertains by the foundation to each of them neither is known nor appears by writings."[42]

Six canons certainly appear on record in 1539, and again in 1544.[43] The prebends coincide, however, in only four instances. As it is unlikely that two established prebends disappeared and were replaced by two others within five years, further strength is given to the view that prebends were associated with the holder of a benefice rather than with the actual benefice held. This, too, explains the appearance of no fewer than eight prebends in the early 16th century, some of which were clearly not in existence in 1544. If the prebends of the archdeacon of Orkney (Birsay and Harray), and that of the archdeacon of Shetland (Tingwall, Whiteness and Weisdale), may have had some permanence, it is not altogether certain whether they were additional to the six simple canons, or formed an integral part of that total.[44]

The only certainty is that Bishop Reid found the situation unsatisfactory and decided to bring his Cathedral constitution into line with that in the majority of Scottish dioceses. If surveys of the medieval Church tend to end on a note of degeneration and hopes of an impending Protestant Reformation, Bishop Reid's intentions lay in a regeneration of the Church from within. In this desire he was not alone, and while contemporary circumstances dictated otherwise, the Church in Orkney during Bishop Reid's episcopate was as alive and well as when Earl Rognvald had first brought his Cathedral to Kirkwall in 1137.

THE 16th CENTURY AND THE MOVEMENT FOR REFORM

Duncan Shaw

O rkney was much involved in the events that followed in the wake of the Reformation in Scotland. It was a bishop of Orkney who conducted the marriage of Mary Queen of Scots to her third husband, the Earl of Bothwell. The same bishop—when the Queen was deposed by her subjects soon after the marriage—went on to officiate at the coronation of her infant son James VI; and the bishop also joined personally in the chase at sea of the Earl of Bothwell, whom Mary had created Duke of Orkney.

The bishop's name was Adam Bothwell, no relation to the Earl, but in his own right one of the most notable figures of an eventful period. He arrived in Orkney at the time of the Reformation, and—like Mary Queen of Scots in her own way in Edinburgh—found himself at the centre of a rapidly changing situation. The islands had become increasingly bound up with Scottish affairs in the previous century, with the transfer of royal rights and estates to James III of Scotland in 1468. The king had acquired the earldom itself two years afterwards, and from then on it was the royal prerogative to allocate the rights of the earldom to whoever seemed most suitable. The holder of the post paid the Scottish sovereign a fixed annual sum for the right to collect and keep all the taxes due to the Crown—the earldom estates were termed to be held in tack, and the holder was the tacksman.

The tacksman was often appointed to other positions of power at the same time, including the new post of Sheriff (a Scottish office, replacing the old Orkney one of Justice or Lawman) which was established by James V, who visited Orkney in 1540. Earlier in his reign, the King had also confirmed the charter of James III in 1486 which gave Kirkwall burgh status and the ownership of the "Kirk called St Magnus Kirk" to the magistrates, councillors and people of Kirkwall—a unique situation in Scotland.

The allocation of the tack of Orkney had major effects

on the islands. Sometimes it went to an able and popular figure, such as Lord Henry Sinclair, who fell with James IV at Flodden. At other times, the holder was highly unpopular, as in the case of Henry's son, who was driven out by the Orcadians and then successfully kept out by the Battle of Summerdale in 1529. When James V died after the defeat of Solway Moss in 1542, leaving his infant daughter Mary as Queen of Scots, Mary of Guise the Queen Mother placed a Frenchman in charge as governor and sheriff of Orkney, which she claimed as her dower for her own daughter's marriage to the late king.

The French connection led to great instability for Scotland, caught between Catholic France and Protestant England. It was only after Mary of Guise's death in 1560 that the Reformation came to Scotland—later than almost any other country. As Regent of Scotland she had brought in French troops to Leith and Fife at the start of the year, to hold down the Scottish reformers; they in turn had received support from the fleet of Elizabeth of England. Two years prior to this, Mary of Guise had strengthened the French hold on Scotland by marrying the young Scottish queen, Mary, to the young Dauphin of France. At the negotiations in France over this marriage, one of the Scottish representatives was Bishop Robert Reid of Orkney. He was a man with wide national connections, who indeed may be regarded as the original founder of the University of Edinburgh, through leaving in his will a sum of money which later bought land for the site.

Bishop Reid's death in 1558 opened the way for Adam Bothwell to come to Orkney to succeed him. The death of the Dauphin of France left Mary Queen of Scots to return on her own to Scotland, as a Catholic monarch in a country turning Protestant. It was she who granted the tack and sheriffdom of Orkney in 1564 to her half-brother Robert Stewart, a decision which led to much hardship for the people of the islands until in the following century a bishop of Orkney—the famous James Law—came to their aid. (Bishops had been replaced by government by presbytery in 1592, but in 1606 King James VI restored episcopal rule).

The opening up of Orkney to Scottish adventurers was a great price that had to be paid for the Reformation. Adam Bothwell was followed in by his relatives by marriage, the Balfours and Bellendens, all eager—as was Robert Stewart

when he arrived—to get a slice of the large Church estates that were becoming available. The formulation of the structure of the new Reformed Church was very open, with much left in many areas to the people who were already in position, such as the bishops. Beneficed clergy attached to establishments like St Magnus Cathedral were allowed to retain for life the bulk of their revenues from the outlying parishes which provided for them. The main exception was that they had to pay one third of these incomes to the clergy of the new Reformed Church that was emerging. They therefore had the choice doing nothing, and keeping two thirds of their former revenues, or of serving in the new church and qualifying themselves to retain the final third.

Much then depended on these clergy in post, if a smooth transition was to ensue—as indeed it seems to have done in Orkney. The man who had the task of keeping the church and the community around it on a smooth course through this stormy time was Adam Bothwell, building on the base set up by his predecessor Robert Reid, a man who had already prior to the Reformation instituted major reforms in the organisation of the Cathedral, as well as rebuilding the Bishop's Palace and providing accommodation for a reorganised Grammar School. The events and issues of the times can be seen through an examination of the lives of these two great reforming bishops, Robert Reid and Adam Bothwell. *(Editorial introduction.)*

In any consideration of the movements for renewal and reform of the Church in Orkney, it must not be forgotten that the events which took place in Scandinavia and northern Germany in the decades prior to 1560 had a quiet and continuous influence—in addition to the changes that were taking place in Scotland, and to a very lesser degree in England as far as Orkney is concerned. The continuing close affinities with northern Norway and the close trading connections with Hamburg and other cities into the Baltic, involving the exportation of dried fish and the importation of provisions, kept the islanders in touch with communities which were experiencing the Lutheran Reformation. It is interesting, for instance, to note that there is a very early German communion card still in the possession of the church in Dunrossness in Shetland which is very similar in

design to the one that is in Aberdeen in St Machar's Cathedral, and which came from Danzig about the middle of the 16th century.

There was also the presence of foreigners who had a more intimate knowledge of such religious changes, such as the German traders known to have been in Virkie and Bigton in southern Shetland about 1567, who were in all probability representative of small groups of German residents which were involved in trade over a very considerable period.

The turbulence of systematic spoiling of religious houses and churches in Bergen from 1520 onwards, with the demolition of the cathedral in Bergen in May 1531, largely at the instigation of King Frederik I of Denmark, must have had a very moderating influence upon the general populace of Orkney and Shetland. The situation of the Church in Norway under Charles III of Denmark was a desolate one: the third article of his epitulation made in the Reichstag of Copenhagen in October 1536 stated that Norway should "hereafter be and remain under the Crown of Denmark and not hereafter be or be called a separate kingdom but a dependency of the kingdom of Denmark." That proved to have a devastating effect on Norway until the end of the 16th century. It can also be assumed that some of the Orkney fishermen were aware of the situation in east Friesland, where Lutheranism was replaced by Zwinglianism in 1528.

The commercial connections between Norway and the diocese of Orkney are illustrated by the commission which on 16th March 1560 was granted to Bishop Adam Bothwell and Alexander Dick, the provost of the Cathedral and official of Orkney, in a case between Hanseatic merchants in Bergen and some Orkneymen.

With the consecration of Robert Reid, who was a Cistercian monk and Abbot of Kinloss, as Bishop of Orkney at Edinburgh on 27th November 1541, a new era for the diocese opened. He was a man of good education, entering the University of St Andrews in 1511, and graduating MA there in 1515. He thereafter studied in Paris. He had obvious administrative gifts and was sub-dean and then official of the diocese of Moray; he was also a Renaissance scholar, as the residue of his library shows.

One of the most important intellectual influences on

Reid emanated from Giovanni Ferrari, whom he met while in Paris on returning from transacting business at Rome for the diocese of Moray. They met again in Kinloss Abbey, where Reid was also a member of staff of the University of St Andrews and had been chosen as the successor to the Abbot, Thomas Crystal. Ferrari remained in the Abbey, and made a scholarly contribution to the life of the house, until his return to Italy in 1537. Three years later, he returned to Scotland shortly before Reid became Bishop of Orkney, and the relationship was so close that Ferrari prefaced his commentary on a man called Pico della Mirandola, on the immortality of the soul, which was published in Paris in 1541, with a dedicatory letter addressed to Reid which was dated 1st November, 1540.

Robert Reid was typical of many churchmen of his time. He was a pluralist, and he was permitted after getting the See of Orkney to retain the Abbacy of Kinloss and other benefices. Yet he was a man with cultural and educational interests. He sent his nephew Walter to study in Paris, in the care of an outstanding Scottish intellectual, Adam Elder; it was stipulated that the nephew's course must include Greek, and he eventually succeeded his uncle as Abbot of Kinloss. Reid also ensured that a man called Edward Henryson, who returned to Scotland under the recommendation of Ferrari, was appointed to lecture in Greek and Law in Edinburgh before the founding of the University. That, of course, is particularly interesting, in view of Reid's subsequent bequest of money for the founding of the University in Edinburgh; and the Reid Chair of Scots Law, in fact, now indicates the connection between the Bishop of Orkney and the University of Edinburgh.

· An understanding of the intellectual background of Robert Reid can be culled from a list of books that were in Kinloss Abbey library and also in his home. One of them, as a matter of fact, now in Aberdeen University Library, was originally found in Kirkwall; the book indicates that it was sold at one time by the library in Kirkwall to the University Library of Aberdeen.

The motto which he chose for his personal arms—*Moderate*—summarises his background of theological orthodoxy with an interest in humanistic and literary, as well as legal, matters. In common with many influenced by the New Learning, Reid remained untouched by any of the

Reformation theologians. He was concerned with renewal and not with reform. His judicial activity in the trial of heretics is witness to the great strength of his orthodox position; he was present as a judge at the trial of Adam Wallace, who was burnt at the stake for heresy in the summer of 1550. There are also two books which we know were in Reid's library—one by Conrad Bruno, *Concerning Heretics*, which was published in Mainz in 1549, and the other by Alfonso di Castro, *On the Just Punishments to Heretics*, which was published in Lyons in 1556.

Now these are evidence that the persecution of heretics was not just a passing interest, but continued to the end of his life. In this connection, it is interesting to note that there is only one case of heresy recorded which has any link with Orkney during the time of Reid's episcopate; but whether this case arose in Orkney or elsewhere is really impossible now to determine. The case concerns James Skea or Ka, a chaplain born in Orkney who fled to England in 1548, as it says, "for fear of burning for the Word of God." Two years later, Kay petitioned for a respite for his crime of "tenascite and pertinessite in halding of oppynionis concerning the faith contrare the tenor of actis of parliament." He was granted the respite on condition that he return to Scotland and "remane thairin . . . and use him as ane subject thairof." Now it cannot be established if he returned to Scotland, as there is no further definite reference to him in extant records, but one wonders if a James Cadie, Reader from 1567 to 1574 at least in Dunsyre (where Adam Bothwell held property), may have been the same man, and thereby assisted by Reid's successor.

Reid took time to consider the changes he should make within his diocese. The reorganisation planned and executed by him was inspired by the spirit of the Council of Trent, and it revealed a conviction that the improvement of Church structures on the basis of constitutional orderliness would effect the improvements necessary to enable the Church to fulfil its role in the turbulent and changing times. Reid's presence at the Scottish Provincial Councils which were concerned with such questions was not perfunctory, as the decisions in accordance with Trent were implemented by him in Orkney. The question often raised is, what the state was when he came here, and it is very difficult to know just exactly what was happening. I venture, however, to suggest

that the difference that exists about how many canons there were in the Cathedral at that time does indicate that probably there were some who were non-resident: they just drew their stipends and were living it up somewhere else.

But Reid took time to consider the direction of the Cathedral chapter and, as his own document says, "after long and mature discussion and consideration with the existing canons of the Cathedral," he set wheels in motion. His main concern was "to ensure the proper liturgical functions of nightly and daily watches so the Divine Service would be so honestly attended to become such a cathedral church." The reforms were agreed to by the benefice holders affected by the proposals, having been cited to appear before the bishop—either personally or represented by a procurator—and having signed the appropriate legal documents.

One of the most important powers which was assumed by Reid in this reorganisation was the right of presentation and collation to all the dignitaries in the cathedral chapter. However, he was not merely concerned with organisational improvements in the structure of the diocese; he had a practical concern for the pastoral and liturgical life of the Church. He owned a book by Francois Pennison, *The Office of the Pastor,* which was published in Toulouse in 1550. He also had a book of the ecclesiastical ritual, which was published in Cologne in 1557, and it is fairly certain that he had a breviary that had been printed in Lyons in 1546. The high proportion of biblical commentaries—all very ortho-dox—in his possession indicate his interest in the sacred text; and his biblical scholarship, although of a very traditional nature, must have had an effect on his diocesan clergy. *The Foundation and Election of Certain Offices in the Cathedral Church of Orkney* of October 1554 is a most detailed document, and witnesses to the care Reid had, not only for the organisation, but for the quality of the staff, both in their scholarship and their disciplined employment.

The Provost was to be a Doctor of Theology, or somewhat less; he was also to be responsible for the correction of all members of chapter, and in his absence the Sub-dean. He was bound to preach four times a year in the Cathedral—in the vernacular. The prebend of Holy Trinity and the vicarage of Ronaldsay with the maintenance of the Church of Burwick were appropriated for the provostry; the first incumbent was in fact not as they had hoped a

Doctor of Theology, but a biblical scholar—Magnus Halcro, who was a Bachelor in Sacred Letters.

The Archdeacon was to be at least a Master of Arts; so that he was able to carry out the Bishop's charges, to the clergy and the people. He also had to preach four times per annum, in the common tongue, as had the Provost. If he did not preach, this was to be treated as non-residence and he was to be fined; and this is the same in every case. The vicarage of Birsay and the chaplaincy of St Olaf within the Cathedral, with the maintenance of the church at Harray, were appropriated for the archdeaconry, and Mr John Tyrie was appointed.

The Precentor had to be an MA or a graduate of some sort, and he also had to have some knowledge of the Gregorian chant. Prior to appointment, he had to be examined by the Provost and two canons and four vicars choral. He was to be personally reproved by the Provost for any defects in the choir. Sir Nicholas Halcro was appointed as Precentor, with the prebend of Orphir and the vicarage of Stenness—and so again these parish fruits were coming in to the Cathedral.

The Chancellor had to be a Doctor in Laws, or at least a Bachelor in Law. His responsibilities were to read publicly once a week the canon law in the chapter house for all the canons and all the elders around the Cathedral. Failure to do this was again to be treated as non-residence and to be fined. He was also responsible for the choir-books, the register, the Common Seal, and also for the library. Mr Alexander Scott was appointed, and the prebend of St Mary's in Sanday and the vicarage of Sanday were appropriated to the Chancellorship.

The Treasurer had to be an MA; he was to be responsible for the ordinance and vestments, in charge of the bread and wine, the oil and the food. He was also responsible for the cleaning and repairing of all vestments, and the cleaning of the altars. Sir Stephen Culross held this appointment, and the fruits of the rectory of St Nicholas of Stronsay and the vicarage of Stronsay were appropriated.

The Sub-dean also had to be a Master of Arts and had to be well-schooled in the Testaments, Old and New. He was responsible for the correction of faults of the chapter in the absence of the Provost, to preach three times a year, and to act as the penitentiary to the bishop. Mr Peter Houston

was appointed, and the rectorship of Hoy and the vicarage of Walls provided his salary. The Subchantor had to be a musician skilled in singing and the organ, and his duties are spelled out in great detail; Magnus Strang was appointed and held the prebend of St Columba.

Finally, there were to be seven other prebendaries, who were to be canons, and had to be ordained priests within a year of appointing—a most important thing, because in the Middle Ages a lot of people were not ordained for years. The duties of all seven are also given in detail. Thus you find that the prebendary of the Holy Cross was to be answerable to the Treasurer for keeping the clock and ringing the bells and so on; the prebendary of St Mary's was the master of works, and he was in charge of the care and the maintenance and the repair of the glass, and the roof of the Cathedral; and the bishop was responsible for the meeting of the cost of these repairs. The prebendary of St Magnus was the vicar and confessor to all the servants of the bishop and the provost and the canons and the prebendaries.

Then of course there were certain people who were appointed to the various chaplainries in the Cathedral, all existing clergy. In addition to the foregoing appropriations, the Cathedral chapter had extra money which was brought in from Walls and from Westray, and from the vicarages of Sandwick and Stromness. So you can see that there was a large amount of money coming in from all over Orkney.

In addition it was specified that there was to be someone in charge of the singing who was to be a Doctor in both Song and Music; six choirboys were to be permanently here, and they were to be nominated and maintained by certain of the prebendaries, who would be responsible for their discipline.

Throughout this document, there is continual reference to the need for continual residence in Kirkwall of all members of the chapter. One of the problems of the Middle Ages was that a lot of people drew their stipends and were never in the parish from one year's end to the other. To counter this, the Bishop, in a special charter assigned to each member of chapter, gave them a piece of ground upon which they were to build a manse within three years of entering into their benefice. All these clergy had been brought into the Cathedral over the years, leaving behind the vicar pensioners—these were the poor souls who were actually

looking after the parishes, and who were merely being paid ten merks Scots a year, and half the victual out of the fruits of the benefice—that is, the actual corn and so on. Under the new reorganisation, they were actually to be kept under the control of the bishop, and if they didn't do their work, then the bishop had to remove them.

Finally, it's interesting that Reid had put in the document: "in any case that this present direction shall by means of this bishop or of his successors be broken or neglected, then the provost and canons shall reclaim against and oppose the same, and not withstanding any lapse of time shall procure with all their efforts and expenses a just reformation at time and place and before the court as circumstances and times demand." In other words, he wanted to be absolutely certain that the reforms that he was bringing in were going to be perpetuated; the nominees that he was installing were thus to be the trustees to ensure that any successor did not overturn the new structure.

One can understand of course Reid's attempt at this legislation. However, it is to be seen as the last blossoming in Scotland of an earlier piety which was primarily concerned with the continual worship of God by the clergy, and the repeated saying of masses for the living and the dead. This had been the earlier inspiration of the establishment of collegiate churches throughout Scotland. The effect of the enlarged staffing of the Cathedral was the impoverishment of the parishes, as under the new foundation the financing was achieved by further withdrawal of parochial revenues. These revenues, had they been retained within the parishes, could have been applied for the recruitment of better-educated parish priests who would have been able to instruct the people in their faith, rather than merely coping with routine liturgical practices.

Reid's solutions for the Church's problems were those offered by a traditionalist, although he was an able constitutionalist who sought to establish an enforceable orderliness in the life of the diocese. He really conceived the Cathedral as being the only heart of the life and witness of the Church in Orkney. He really did not appreciate the new spiritual expectations of the people. Nor was he aware of the fundamental questions which were being raised in the minds of so many pious people, who in the end saw no other way than to depart from the very principles which had inspired

his final attempt at an orthodox reform of the Church.

Robert Reid died on 14th September 1558, and the temporality of the see was granted on 22nd March 1559 to Sir John Bellenden, who was Adam Bothwell's cousin. On 2nd August of that year Adam was provided by the Pope to the bishopric of Orkney, and was admitted by the Crown to the temporality of the see two months afterwards. The exact date of his consecration is not known: certainly suggestions by Mr Craven in his books are really only a guess. Adam was thus involved in the diocese before the meeting of the Reformation Parliament the following year, and appears to have been primarily concerned at the beginning with his own financial affairs in connection with pension and other provisions, which were an inevitable consequence of Papal provision to a major benefice. (Various people had to be paid off or bribed, and a heavy financial burden had to be taken on by a successful candidate as a result).

Adam Bothwell would have been well aware of the motivations of Reid which had influenced the administrative changes which he had made. Reid was a founder member of the College of Justice (Court of Session) from May 1532, along with Adam's father, Francis Bothwell, and Richard Bothwell (his uncle). Francis and Richard were the sons of Richard Bothwell, who had been the Lord Provost of Edinburgh a decade prior to the establishment of the College. Robert Reid was Lord President of the College of Justice from at least February 1549 until his death in 1558.

Bothwell had support for his provision to the bishopric of Orkney from his brother-in-law Gilbert Balfour, who was married to his sister Margaret. (His other sister, Janet, married into the Napier family, and her son—Adam's nephew—became one of the greatest Scots of all time: the mathematician John Napier of Merchiston, inventor of logarithms. Adam's mother, Katharine, was a Bellenden, sister of Thomas Bellenden of Auchnoule.) Gilbert Balfour was Master of the Queen's Household, and it was he who went to Rome to obtain the Papal bull which gave Adam the Orkney appointment. Within a few months of the new bishop's arrival, Gilbert was in Orkney to receive the feu of the Church lands in Westray and Papa Westray. (Gilbert Balfour was implicated, along with the Earl of Bothwell, in the murder of Mary Queen of Scots' second husband, Lord Darnley, but when the Earl fled north to claim the dukedom

granted by the Queen, he found no welcome. Gilbert
Balfour refused him entrance to Kirkwall Castle and to
Noltland Castle in Westray, while Adam Bothwell joined the
pursuit of Bothwell's ships to Shetland.)

But Adam's main link to Orkney to begin with was
through his mother, who on the death of Francis Bothwell
had married Oliver Sinclair of Pitcairns, the last of James V's
favourites, appointed in former times by the king as
tacksman and sheriff of Orkney. Oliver Sinclair had indeed
led the Scottish army at Solway Moss in 1542; his failure
there and the death of James V a few weeks afterwards led to
his downfall. He was the son of Sir Oliver Sinclair of Roslin,
a nephew of Sir David Sinclair of Sumburgh in Shetland, and
a grandson of William Sinclair, last of the old Earls of
Orkney and Caithness and Lord Chancellor of Scotland.

Oliver Sinclair already had two bishops in the
family—his twin brothers Henry and John, in Ross and
Brechin respectively.

John Sinclair was Lord President of the Court of Session
when Adam Bothwell was promoted to the bench. Oliver's
connections with the Reformed Church were not so good,
however: he was considered by John Knox to be "an enemy
to God", and the two bishops John and Henry remained
true to Rome. They too were strongly disliked by Knox:
Henry Sinclair was described as "a perfect hypocrite and a
conjured enemy of Christ Jesus whom God after struck
according to his deservings" while John Sinclair was
considered to be "blind in ane eye in the body but of baith
in the soul."

In spite of the problems of taking different paths, these
relationships must have proved useful to the new bishop and
may in fact account for his somewhat careful approach to
the Reformation movement. When Bothwell succeeded Reid,
the changes were not as abrupt as they might have been in
other circumstances. They shared a common interest in the
law, at a high intellectual level, as the remains of both
libraries indicate; although undoubtedly quite a number of
Bothwell's possessions had been inherited from his father and
uncle. Yet their common interests did not stop there. They
were both Renaissance scholars, whose wide cultural
background was the source of an awareness of much
contemporary scholarship.

There was however a considerable difference in their

theological position, as is apparent when a comparison is made of such books as now remain from each library. Here is to be found the fundamental inspiration of the reforms which were undertaken by the new bishop. The theological literature in Bothwell's library, which is very considerable, indicates that he had a wide knowledge of most important theologians from the various centres of Reformation law, post-Lutheran works from Germany, and a wide range of books from Zurich and Geneva. There is little evidence of English Protestant books, but no definite conclusions can be drawn from this as the catalogue of the library only mentions English books without listing them. He was however interested in the Scandinavian area as he had two volumes by Niels Hemmingsen, the Danish Lutheran theologian, and it's interesting to notice that James VI himself possessed four works by the same author.

Adam Bothwell's interest in the Bible is shown by the large number of biblical commentaries by all the Reformed theologians and biblical scholars, and he also had an edition of the Bible in Hebrew. He knew the biblical languages, as some manuscript additions to one or two of his books indicate, as well as his grammar and other books which he had on Hebrew and Greek. To judge from the library as a whole, there is little doubt that Bothwell was prepared to learn from Reformation theologians of whatever country or particular theological school.

His attitude to liturgical practices would also appear to have been far from rigid. The Book of Common Order has not survived in his library; part of the reason may be of course that the first edition did not appear until he was almost on his way out from Orkney. But he may have been somewhat old-fashioned in his views on public worship, as is illustrated in his defence of the anointing of the infant James VI at his coronation in 1567. (John Knox preached at the coronation, but did not take part at the anointing.) The bishop anointed James VI on his head, his shoulder-blades and his hands, "saying certain prayers before in the English tongue," and at the end of the service gave the blessing.

Now of course it's interesting that there is no written liturgy for the coronation of James VI, and so Adam Bothwell must have made up the service himself; which of course is quite in accordance with the Book of Common Order because it is a book of Common Order and not

Common Prayer. Of course the reason for the continuation of the medieval coronation rites may also be prompted by the lawyer in him, with certain constitutional considerations rather than liturgical. However, one can only wonder what type of Reformed marriage service he used when officiating at the wedding of Mary Queen of Scots and the Earl of Bothwell.

Adam Bothwell was certainly not strict in his oversight of his diocese in such matters, as it was not at his instigation that in November 1567 the late conformer Alexander Dick, the provost of the Cathedral, was indicted for saying mass in contravention of the proclamation which had been issued by Queen Mary on her return to Scotland in August 1561. Dick was also accused of adulteration of religion. This probably meant little more than the conducting of public worship in ways other than in conformity with the Book of Common Order, as it is certain that Bothwell would not have countenanced the saying of mass in his diocese, and particularly in the Cathedral by his provost.

The initiative of the Scottish bishops in operating reforms within their diocese has been considered in great detail by Professor Gordon Donaldson, and this paper owes very much to his researches over the years and his recent book (*Reformed by Bishops*, 1987). It is important to note that in Orkney, as in Caithness and Galloway, it cannot be said that the Church of Scotland, as has been often claimed, was reformed by presbyters. In many ways, the methods of Bothwell were very similar to what had taken place in many English dioceses. (And there is an article by F. T. Price which appeared fifty years ago, which offers an interesting account of changes which took place under Bishop John Hooper, in Edwardian times, in the diocese of Gloucester).

Bothwell could not have set out for his diocese at a worse time, on his appointment. He was captured by the English on 11th February 1560, the English fleet having arrived in the Firth of Forth the previous month, to cope with the problems that Mary of Guise was creating. He was in captivity for several weeks, but nevertheless was soon released and reached Orkney in April. He stayed on this first visit until April the following year.

It seems that he had already made up his mind about central diocesan administration, for he took staff with him, who were to remain in control during the bishop's absences

from the diocese. Mr Gilbert Foulsie, a former monk and priest of the diocese of Aberdeen, came as his secretary. He was appointed to the prebend of St John, succeeding James Annand who was appointed chancellor. Shortly afterwards, Foulsie was promoted to the archdeaconry of Orkney; and in addition to his other duties, he was minister of Birsay and Harray, the parishes which provided his stipend as an archdeacon. William Lauder, an MA from Glasgow, who had acted as a notary there in 1558, succeeded Foulsie as secretary and subsequently became minister of Yell and Fetlar. (They may seem remote, but they were quite valuable benefices in those days.)

The other member of the secretariat was Francis Bothwell, an ex-friar, who had matriculated at St Leonard's College, St Andrews, in 1537. St Leonard's was the most liberal of the colleges of St Andrews, and there most of the Protestants were trained. Francis was a nephew of Adam, and he became prebendary of St Augustine by 21st October 1560, and within a short time became Treasurer of the Cathedral. His income came from the fruits of Stronsay, Eday and Fara, and his ministry there seems to have begun in 1561.

The diocese administration was also strengthened by the appointment of James Alexander, another of the bishop's clerks, as Commissary of Orkney, a necessary continuing legal organ in testamentary and matrimonial matters. It should be noted that the Bishop, with elders and deacons of Orkney, gave judgment in a divorce case on 8th August 1562. Now from this case it is obvious that within a very short time from the Church being reformed in Orkney, there were elders and deacons appointed in accordance with the Book of Discipline, and a synodical administration functioning in exactly the same way as in other areas. (St Andrews is the best documented, and parallels can be drawn).

Bothwell also used local clergy skilled in the law; John Gifford, who had been in Orkney since 1553, and had been a vicar choral in the Cathedral from the following year, appears as a notary in 1560 and very shortly afterwards was appointed a reader, and then later a minister in Northmavine.

One of the significant questions which arose at the Reformation, which was particularly relevant to the diocese

of Orkney, especially after the fate of the cathedral in Bergen, was the place of the Cathedral and its chapter within the new structure when the fresh emphasis of the exclusive place of the parish church in the Reformed Church in Scotland was actually coming to the fore. The Book of Discipline was quite specific; "As we require Christ Jesus to be truly preached, and his Holy Sacraments rightly administered, so we cannot cease to require idolatry, that is, all monuments and places of the same, such as cathedral churches, other than presently are parish churches or schools, to be utterly suppressed in all bunds and places of the realm."

This attitude was also widely held within the Church of England, from the time of the constitutional changes made by Bishop Reid, which would not have been commended by the English Reformers. The precise meaning of the phrase that these institutions were to be "utterly suppressed" has been raised. It is certainly arguable that this need not necessarily be synonymous with "cast down," a phrase often used by the Reformers, as most of the cathedrals in Scotland did not become ruinous until after 1600. The future of St Magnus Cathedral—which from the beginning of the Reformation was used as a parish church—was assured. Bothwell, by the way, had a personal interest in architecture: in his library there are two books, one in Italian by a man called Cantanio, entitled *Four Books concerning Architecture,* and another one in three parts by a scholar called Servia.

Now of course the position of Orkney Cathedral was further reinforced when the Regent Morton reported to the General Assembly in 1573 that where a cathedral was being used as a parish church, it had to be maintained until the Three Estates decided otherwise. Apart from the removal of furnishings and fittings appropriate to Roman Catholic liturgical use, St Magnus Cathedral appears to have been unharmed by the changes wrought by the Reformation. The financing of the maintenance of the building was the concern of Parliament in 1633, when it was proposed that the nave should be upheld from the patrimony of the Crown, while the choir was to be kept in order by the bishop. There is a long history of the ways in which the repair and maintenance of the Cathedral were funded.

During the events which led up to the first meeting of the General Assembly after the Reformation Parliament,

Bothwell was in Orkney, and seems to have spent most of his time in the Yards, the Bishop's Castle. Apart from the clergy which Bothwell brought with him, he found a nucleus of educated and reliable incumbents; this, I am quite sure, had something to do with the reforms that Robert Reid had brought in about standards of education for certain appointments.

James Annand, who had been prebendary of St John since 1558, became the chancellor about the time of Bothwell's arrival; the chancellory was endowed with the parsonage and vicarage of Our Lady in Sanday, the vicarage of Holy Cross and St Colm in Sanday, and the vicarage of North Ronaldsay. Annand was also appointed to the parsonage of Holy Cross in Westray. Thus he became minister of Sanday, North Ronaldsay and Westray, from 1561 until 1584.

The position of Magnus Halcro, who had been chantor since 1555, was parson and vicar of Orphir, vicar of Stenness, and vicar of Firth. He married after the Reformation's ending of the requirement of celibacy of the clergy. As the parishes of Orphir, Stenness and Firth have no indication of another minister until 1567, and as Halcro did not pay up money to the collectors who were collecting money from those not actually officiating in parishes, it may well be that he served in the parishes for a time, but certainly fell by the wayside, because he was excommunicated later for adultery.

Magnus Strang the subchantor may also have served in the parish of Sandwick, but he was dead by 1562. Alexander Dick, the provost of Orkney from 1554, enjoyed the fruits of the parsonage and vicarage of Our Lady in South Ronaldsay, the vicarage of St Peter there and the vicarage of Burray, and he was very ambivalent; we are not very sure of when he actually became minister, but he served these parishes from at least 1574.

The less educated clergy appear generally to have been more disposed to conform at the Reformation; although for ten merks a year, we cannot say that they were very induced by financial considerations. James Maxwell was vicar of Stronsay, prebendary of St Catherine and chaplain of Holy Cross for twenty years before the Reformation, and actually served for another thirty years after it. Thomas Rattray was vicar pensioner in Shapinsay, and he served from at least 1561. A considerable number of other vicars pensioner

conformed and continued to serve their parishes as readers: Gavin Watt in Deerness, David Anderson in Evie, John Duncanson in Sandwick and Stromness, Laurence Young in Rousay, John Mallison in Walls, and William Brown in Westray.

Some proved themselves to be competent, and were later appointed *exhorters*; that was a little bit better than readers, although I don't think there was any extra money. Exhorters were allowed to conduct services and preach, but not to administer the sacrament. One of those was Laurence Young, vicar of Rousay, who was appointed exhorter in 1568.

Bothwell's second visit to Orkney in the summer of 1562 saw a further increase in parochial staff. But there was one problem which was still facing the Church throughout Scotland, namely the financial provisions for the payments of ministers and readers from the money that was being collected from the benefices (from the thirds of revenues from those who elected not to join the new Church). It was not until December 1562 that a committee of the Privy Council allocated stipends and other payments to ministers, exhorters and readers, on the basis of recommendations made by the superintendents (the official organisers and administrators of the new Church). Payments were made for the financial year ending 25th March 1562, but the money was only paid at the end of the calendar year 1562. Thus the first payments were received more than a year in arrears. As this is often the only source from which information can be gained, it is difficult sometimes to know exactly when people did actually enter into the Reformed Church; but it's fairly certain that a large number of these men whom we know were serving from the time of March 1561 probably continued in their benefices over the whole period.

In subsequent years, those who had served within the pre-Reformation Church and reformed, did not have to give up any of their pre-Reformation salaries and they simply retained them, while the others were paid regularly. In the case of Bothwell himself, he did not actually pay up the third which he was supposed to pay up in 1561; presumably he considered it wasn't required of him, as he was exercising his ministry within the Reformed Church—and in fact in 1562, he received for 1561 and 1562 an extra £300 for each year for, as is said, "his visitatioun, ovirsycht and lawbouris,

tane upoun the kirkis of Orknay and Zetland in place of a
superintendent."

As far as the central administration of the Church is
concerned, Bothwell is probably associated with some of
those in Edinburgh who were involved in the development
of the General Assemblies, although there is little or nothing
in the residual records of the Assemblies until June 1563
regarding his involvement in meetings of the Assembly. (He
was in Orkney in 1561 and in 1562.) In June 1563, he and
the Bishop of Galloway and the Bishop of Caithness were
commissioned to act as superintendents within their dioceses,
but this was merely legalising the existing situation.
Bothwell's presence at most of the Assemblies from that date
until 1566 is recorded; his membership of the Commission
set up by the Assembly of 1563 to revise the Book of
Discipline shows their respect for his legal knowledge,
although nothing came of this commission's deliberations.

His acceptance of an appointment as an extraordinary
senator of the College of Justice in January 1564 and as a
Lord Ordinary in November 1565, which was criticised by
some members of the General Assembly, may have been
motivated by an awareness that he did not fit well into their
structure and outlook, to which he was not fully committed.
His absence from the diocese from November 1564 seems to
confirm this. From November 1564 to the summer of 1567
he seems never to have been absent much from the Court of
Session. Even though he was away from his diocese,
however, he was in fact closely involved in appointing
ministers to benefices; and quite a number of the clergy from
Orkney appear to have been in Edinburgh from time to
time, because they witnessed certain of his documents
stamped in the city.

The list of benefice clergy for the year of 1567 is
certainly the best we have, and indicates that by that time
almost all the parishes in Orkney were actually filled by
ministers, readers or exhorters. Now the law and practice of
the Church being as they were, someone would have had to
examine and admit all those ministers and readers. This
would have had to be either Bothwell himself or his deputy
Foulsie, as for that period no one was allowed to admit
anybody to a benefice, apart from the bishop. This is, as
Professor Gordon Donaldson points out, a creditable
achievement for Bothwell, because it seems that there is no

doubt that, compared with all the other dioceses in Scotland, Orkney and Shetland were at least better staffed than most, and certainly well above average; and it's interesting that the position that was achieved in 1567 remained almost unchanged in the subsequent records of 1574 and 1576.

But in December 1567, the Bishop found that he was in bad odour with the General Assembly. He hadn't been visiting his diocese as he ought to have been; and various other accusations were put to him. One of these was, of course, that he had solemnised the marriage of two adulterers, namely Mary Queen of Scots and the Earl of Bothwell, contrary to the Book of Discipline. And so he was deprived from the ministry; but of course by that time, Bothwell was really on the way out. He was rehabilitated by the General Assembly in July 1568, but things were in fact moving to a very sad situation, because his position in Orkney was proving to be untenable. Lord Robert Stewart was attempting to ease him out of Orkney, in an effort to take over all the property which was owned by the Bishop.

What in fact did happen was that Adam Bothwell made over in feu all the lands, the mills, and the fishings of the bishopric, and set the entire revenues of the bishopric from lands and teinds in tack to Robert; in exchange he received the lands of Holyrood. Now of course, Adam Bothwell technically remained a bishop; and it is true that he still had, as it were, some spiritual authority; but he never received any further commission from the General Assembly, and we can say that from his moving to the south and Holyrood House, he actually moved out of the affairs of the Church. The future in Orkney was left in the hands of those who were appointed as Commissioners in place of superintendents to keep an eye on the diocese, the first two of these being James Annand and Gilbert Foulsie together.

But Adam had laid secure foundations. The men who were in the parishes appear, on the whole, to have carried out satisfactory ministries, and we move on until the end of the century in a fairly static position that had been outlined by the bishop. The financial resources of the collectors of the thirds of the benefices made the financial structure of the parishes such that they were able to continue, and then we move in to the period of the first episcopate; but that's another story.

THE EIGHTEENTH-CENTURY CHURCH IN ORKNEY

William P. L. Thomson

I n tracing the origins of the eighteenth-century Church, it is necessary to begin a dozen years earlier with the Revolution of 1688 when James VII was replaced by William and Mary, and when bishops were replaced by presbyteries. It was a shattering event as far as the Church in Orkney was concerned. In terms of the clergy who refused to be reconciled to the new regime, 1688 was a more complete break with the past than even the Reformation. Only the Rev. James Graham of Holm accepted Presbyterianism with any enthusiasm. Other ministers and the great bulk of the laity remained attached to Episcopacy with varying degrees of commitment.

While William of Orange's natural inclination would have been to rely on the Scottish bishops, the fact that they continued to support the exiled James VII made that impossible, and so he was forced to turn to the Presbyterians. In 1690 a General Assembly was recalled, composed mainly of those ministers who had been deposed from their charges after the restoration of Charles II. These 'Antediluvians' as they were called were an elderly and embittered minority, intent on revenge rather than reconciliation. But in Orkney there were no Antediluvians; the two ministers deposed in 1662 had long since departed the islands,[1] and so initially there were no ministers who could form the nucleus of a presbytery. It was in fact a further nine years before a rudimentary presbytery could be established, and even then it consisted of only three ministers.[2] Because it was so small, its powers were strictly limited by order of the General Assembly.

To assist the infant presbytery, Commissions of the General Assembly visited Orkney in 1698 and again in 1700,[3] and these Commissions undertook a purge of Orkney ministers. The Rev. John Wilson, the Cathedral minister, had

already been deposed in 1694 by order of the Privy Council, although he remained in Kirkwall and continued to minister to a large part of his former congregation from a meeting-house in Anchor Close.[4] The Commissions proceeded to rout out and dismiss the remaining unrepentant Episco-palians, Alexander Pitcairn of South Ronaldsay, George Spence of Birsay and Harray, James Leslie of Evie and Rendall, and Thomas Fullarton of Westray.

Elderly ministers who were unwilling to take their place in presbytery, but who were nevertheless prepared to live quietly under the new regime and to pray for William and Mary, posed a different problem. These included the Rev. James Heart in Shapinsay who was grudgingly allowed to remain, and Alexander Dalgarnoch in Walls and Flotta who was permitted to retire on a small pension. Of the pre-1688 ministers, the only one who actively sought acceptance was the Rev. Richard Mein of Cross and Burness in Sanday. Before he was admitted, witnesses were called so that the Commission could investigate charges of tippling and card-playing, and could discover the truth about his alleged part in theatricals which took place at a 'feast' at Stove, the highlight of which was the moment when the minister appeared with blackened face and, standing on a chair, delivered the memorable line, "Cape and Gloure! Who will have or kiss me now?"[5]

There were problems too with those ministers who had come to Orkney after 1688 since, in the absence of a presbytery, there was no proper ecclesiastical authority to confirm them in their parishes. Some, like the Rev. Alexander Keith who had been rabbled and driven out of his former parish of Tillycoultry because of his Episcopalian views, became established in Orkney simply on the basis of a call from the parish without reference to either bishop or presbytery. Others, like Patrick Guthrie of St Andrews and Alexander Mair of the Cathedral second charge, had accepted ordination from deposed bishops. Two ministers of Presby-terian principles, John Cobb in Stronsay and Thomas Baikie in the Cathedral, travelled south to be confirmed in their parishes by already existing presbyteries in Glasgow and Aberdeen respectively.[6]

Each minister had to resolve his predicament according to his own conscience. For some, the question of church government was of little importance. When in later life

Alexander Mair was asked how he came to desert the Episcopalians, he was able to reply with the light-hearted remark, "What will a man not do for his bannock?"[7] For others it was not so easy. Alexander Burnet could not bring himself to take part in presbytery, but asked permission to live peaceably under the new regime; he craved "only a little respite seeing he is a dying man". In actual fact he was still alive sixty-six years later, so his fears of his imminent demise were somewhat misplaced. However, after much soul-searching he suddenly declared that "he would rather go to the grave, or to the Indies, before he went one step farther"; as long as he was undecided he had no peace with his conscience, but now that he had made up his mind to give up his parish for his principles, "he had peace and contentment".[8]

These inquisitions of 1698 and 1700 were conducted in a spirit of great bitterness, and habits of legalistic fault-finding continued to characterise the early part of the eighteenth century as Presbyterians and crypto-Episcopalians attacked each other with charge and counter-charge. This is the background to the story of the Orkney fisherman who declared that he had read in the Bible that the devils had entered into the swine but now, he said, they had come out of the swine and gone into the ministers.[9] Alexander Ker of the Kirkwall second charge was suspected of being on over-friendly terms with the minister of the Episcopalian meeting house,[10] and this lay behind repeated charges against him in presbytery and synod. He was several times accused of drunkenness as, for example, "when he had been at Lingro at the ale",[11] there were charges of impropriety with female parishioners,[12] and rumours were put about that there were occasions when the maidservants in his household found it safer to go about in twos.[13]

Accusations of this kind were not all one way; the Rev. James Sands who wrote pamphlets[14] attacking episcopacy found himself accused of everything from adultery[15] to sheep-stealing.[16] Similarly when the Episcopalians were trying to resist the presentation of the Rev. Andrew Graham to the parish of St Andrews, they charged him before the presbytery with having been so drunk that he had interrupted a meeting of the Justice of the Peace and held a long conversation with John Stewart of Brugh under the impression that he was actually speaking to George Baikie of

Tankerness. On another occasion, in the words of the charge, he was "hugely overtaken and senselessly stupified with drink to the scandal and amazement of several gentlemen".[17] However, the presbytery set a date, not for the trial, but for "the vindication of Mr Graham", showing that the political nature of the charge was clearly understood, and that the presbytery itself was a party to this faction-fighting.

Although Presbyterian ministers became established following the Commissions of 1698 and 1700, they did not necessarily have an easy life. Thomas Baikie more than once sought, and was refused, permission to resign from the Cathedral because of "the many discouragements" he faced. He was greatly offended by what he described as "wicked and aetheistical verses", apparently composed by the Rev. Thomas Fullarton of Westray, which circulated in the town to Baikie's acute embarassment.[18] Unfortunately the "wicked and aetheistical verses" have not survived. Then one Sunday in January 1703 when there was to be no service in the Cathedral on account of his illness, Baikie was astonished to hear the church bells summoning the people to worship. Rising from his bed, he discovered the deposed minister, John Wilson, about to conduct the service. Episcopalians, hugely amused by the whole affair, described how Baikie, "guarded" by his wife, entered the church still wearing his night-cap, and how the two of them "violently pulled Mr Wilson out of the pulpit".[19]

Presbyterians in country parishes where the dominant landowner was Episcopalian were even more uncomfortable. Both John Cobb in Stronsay[20] and James Graham in Holm[21] had church services interrupted when their preaching offended the laird. But the worst placed was John Keith in Walls and Flotta who in a letter to the presbytery described a frightening degree of isolation. His congregation had demanded that he preach "a superstitious service" at "Pasche" (Easter); he described how William Allan's wife, "a most haughty and insolent woman," and Thomas Moodie in Manclet, "a mad fool", had interrupted his preaching and reviled him in the face of the congregation. The minister congratulated himself on the very Christian way in which he had behaved—"no peer of the realm would have dared to treat him like that". Keith was totally ostracised by the community; no one would talk to him, his wife was

pregnant but no one was willing to act as servant in his
household, and he had nowhere suitable to stay since the
manse was ruinous and the laird was deliberately delaying its
repair.[22]

Despite the great bitterness between Episcopalians and
Presbyterians, differences in the form of worship were in fact
few. Evidence given to the 1698 and 1700 Commissions
enables us to reconstruct the normal order of service in fair
detail. The hour of service could be somewhat variable,
especially in the islands; it was James Heart's custom in
Shapinsay to begin some time between 10 and 11 a.m. in the
winter months, but rather later in summer. A first bell
summoned the people to worship, and on the ringing of a
second bell they entered the church. Worship began with the
singing of a psalm led by the schoolmaster who, whatever
his musical talents or lack of them, was expected to act as
precentor. By the eighteenth century music was at a low ebb;
in most churches only about twelve psalm tunes were in use,
all of them in common metre, and the practice of 'lining'
had come to be adopted whereby the precentor sang the line
and the congregation repeated it to the complete destruction
of any musical effect.[23] On the ringing of a third bell the
minister entered; he had no special vestments, and wore a hat
on his head. After extempore prayer there followed the
'lecture'. Presbyterian ministers at the beginning of the
eighteenth century did not read from the Bible but 'lectured'
instead. Originally the lecture had consisted of a Bible
reading with verse by verse commentary, but in the course
of time comment had so overwhelmed the reading that the
lecture became a preparatory sermon.[24] In a non-stop solo
performance the minister proceeded from the lecture to
prayer to the sermon proper; then the service ended with
prayer, a psalm and the benediction. A conscientious
minister was expected to provide an afternoon service
following the same pattern but with the omission of the
lecture. Few Orkney ministers seem to have done so,
although sometimes the Sunday afternoon was devoted to
the task of examining knowledge of the Shorter Catechism.
Even John Brand, one of the Commissioners of 1700,
agreed that ministers were "happily posted" if they had only
one church.[25] Right back into the Middle Ages nearly all
Orkney charges had been joint parishes, and some consisted

of several islands. Claims that eighteenth-century ministers used these difficulties as an excuse for a lax routine are only partly true.[26] In most parishes a service of a kind would be provided, perhaps by the schoolmaster, when the minister was elsewhere. However, on these occasions there was no sermon, and a large part of the congregation took this as an excuse to stay at home.[27] For the minister himself, the difficulties of serving more than one island could lead to all sorts of frustrations. Late one night when there was a long delay before the Burray ferry appeared to transport the Rev. Alexander Pitcairn home to South Ronaldsay, the minister's temper got the better of him; picking up a tangle from the beach and wielding it as a club, he showered blows upon the tardy ferryman.[28]

Episcopalians followed the same order of service with only minor differences which included the use of the Lord's Prayer, creed and doxology (but not the Prayer Book).[29] Anything which was a set form of words, even the Lord's Prayer, was looked on with suspicion by the Presbyterians. In a memorable Cathedral service Thomas Baikie attacked the Episcopalians and their litany "Lord have mercy upon us, Christ have mercy upon us". He argued that this kind of repetitive phraseology derived from Baal-worship. A hostile account describes how, warming to his theme, he began to thunder out "O Baal save us, O Baal save us", and frightened some of the congregation "out of the church, and well-nigh out of their wits".[30] It was only in 1710 when the Justices of the Peace and Presbytery drew up the agreement known as the Mutton Covenant (so-called because it was the result of a working supper) that a compromise was reached whereby the presbytery agreed to recommend that the Lord's Prayer should be used at the close of the service as a means of winning back some of those who worshipped with the Episcopalians.[31]

Sermons were judged on their length as well as their quality, and indeed ministers were considered deficient if they could not preach a series of sermons from a single text. A famous story tells how a Shetland minister contrived to preach for a year and a half from the verse in Exodus which describes how the Children of Israel, having crossed the Red Sea, "next they came to Elim where there are twelve springs and seventy palm trees". He devoted the first twelve Sundays to the twelve springs, and then went on to preach a further

seventy sermons, one each on the seventy palm trees.[32]

An interesting series of sermons preached by Thomas Baikie in St Magnus has been preserved.[33] What remains is the second of two manuscript volumes, suggesting that the series might have extended to about forty sermons and 900 pages of closely written text. His broad theme was the Commandments, but each sermon had a title, Against Slander, Against Cheating, Against Adultery, Against Rash Anger, Against Perjury, and so on. Some had exciting-sounding sub-titles; for example, Against Murder was sub-titled 'The Cry of Blood', but those in search of excitement are likely to be disappointed. The sermons were prepared with great care; little marginal notes show that Baikie was familiar with Latin, Greek, Hebrew and French, and he illustrated his theme with a wealth of Biblical examples. These sermons are, in fact, textbook examples of the moral preaching for which eighteenth-century Moderate ministers were so much criticised by their nineteenth-century Evangelical successors.

Despite the Jacobite sympathies of many Orkney ministers, the Rev. Alexander Pitcairn seems to have been the only one to give free expression to his political opinions from the pulpit. Hostile parishioners gave evidence to the 1698 Commission about a memorable sermon in the South Parish of South Ronaldsay when Pitcairn had not only prayed for the "late king" (i.e. the deposed James VII), but he had told his congregation that it was "a villanous traitor" that had put him from his throne; "it is a wonder of mercy that the Blood of King Charles did not cry for vengeance on the land". Pitcairn was impressed by the terrible harvest failures of King William's reign when many of his parishioners were literally dying of starvation, and he saw this as divine punishment. He contrasted the good times which Scotland had enjoyed under successive kings from the time of James II to James VII with the troubles which had followed the Revolution of 1688 and the exile of the Stuarts.[34]

If the order of service was austere, so were the surroundings. Heritors were frequently neglectful of their legal duty to keep the church in a good state of repair.[35] When the parish ministers wrote the *Statistical Account* of their parishes in the last decade of the eighteenth century,

the church in St Andrews was "ruinous and dangerous",[36] the old church in Deerness was "small, ruinous and irreparable",[37] in Hoy "the whole church about nine years ago fell down of itself" and it had been rebuilt "in a very slight manner",[38] Flotta had stood roofless for many years before it was repaired,[39] Graemsay [40] and Wyre[41] were both "ruinous", and in Eday there had not been one pane of glass in the windows "in the memory of any man living".[42]

In Evie and Rendall the situation was even worse. The minister reported that when he first came to the parishes, the churches were "poor small houses thatched with straw"; the Evie church had not had a pane of glass or even a window frame in it for many years, and in 1781 it had officially been declared ruinous. It was decided that a new central church ought to be built but, as the years went by, nothing happened. Eventually the minister was forced to abandon the Evie church, and it was fortunate he did so, for eventually the walls toppled down on a Sunday when the people might have been at worship. The Rendall church was little better and it too was abandoned in 1794, the minister "having lost his health by officiating there". Three years later no services were being conducted in the parishes, except in the churchyards.[43]

Generally the Cathedral was kept in a better state of repair although, with reduced funds, it was a constant struggle to maintain the fabric of such a large building. In the Session's records it is possible to sense the pride of the congregation in the ancient church, and also to sense the urgency with which it reacted to the major structural damage which occured from time to time.[44] The Seater family, first David, then James, and later David and William, were employed on a regular basis and were paid an annual retainer, with additional payments when there was extra work to be done. In 1740 when there was storm damage to be repaired, the Seaters were dissatisfied with the extra payment they were offered. They appeared before the Session, angrily threw down the keys, and declared that in future the Session could employ whoever it thought fit. However, the Session was not to be intimidated; it pointed out that the Seaters received 100 marks per year, plus two pairs of shoes, and in addition they received the fees from marriages, burials and baptisms amounting to £34 Scots.[45]

Despite all the efforts to keep the building in a

reasonable state of repair, a medieval cathedral was ill-fitted
to eighteenth-century worship. The partitioned-off choir
formed the parish church, walls received an occasional coat
of whitewash, and the congregation was accommodated in
haphazard pews and galleries, the construction and owner-
ship of which were constant sources of dispute. These
structures were painted in garish reds, blues and yellows
which, in Sheriff Peterkin's opinion, were colours better
kept for ploughs and carts rather than the interior of an
ancient church.[46] The outer part, the nave, lay abandoned, its
pillars green with moss and its floor uneven from its use as a
burial place. Little light penetrated into it, since three-
quarters of the windows were closed up.[47]

 In 1701 the Presbytery objected to the Town Guard
stationing itself in the nave at the time of the Lammas
market, "shooting off guns, burning great fires on the graves
of the dead, drinking, fiddling, piping, swearing and cursing
night and day within the church, by which means religion is
scandalised".[48] Even so the guard might have been allowed
to remain had they not amused themselves by "most rudely
pursuing the ministers with muskets and halbards" when
they entered to attend a Presbytery meeting. Whatever
virtues eighteenth-century worship may have had, it had
little sense of beauty either in the order of service or in the
dignity of church buildings. In many ways, the eighteenth
century marks the low point in the history of the Cathedral.

 Following the purging of the Orkney Church in 1698
and 1700, ministers were henceforth appointed in a regular
manner. After the Patronage Act of 1712 this meant that all
ministers, with the exception of the two Cathedral
clergymen, were the nominees of the Earls of Morton. In the
case of the Cathedral, presentation was vested in the Town
Council by right of the royal charters of 1486 and 1536
which not only conveyed "St Magnus Kirk", but also the
"right of patronage within our said burgh".[49] However, this
was a right which Earls of Morton attempted to dispute for
much of the eighteenth century.

 The first Cathedral vacancy following the Patronage Act
occurred in 1723 when Mr Ker left to become parish
minister of Ruthven. Thomas Baikie was glad to see him go;
the two Cathedral ministers, having opposing views on
church government, had been awkward colleagues, often at

loggerheads. There seems to have been a good deal of confusion about how Ker's successor ought to have been appointed, although Mr Baikie, having denounced the Patronage Act from the pulpit, should have known how the system worked. A call was given to William Scott by the congregation, and a number of magistrates were certainly associated with this call, although initially no separate presentation was made by the Council. Then, much to the Presbytery's confusion, the Earl of Morton's Steward-depute appeared to deliver a presentation of Mr Scott. Later that day the Presbytery met the magistrates who by that time had also drawn up a presentation of Mr Scott, so the Presbytery received two rival presentations, albeit for the same candidate. It called for the Kirkwall charters to be produced and, having examined them, decided that the right of presentation lay entirely in the magistrates' hands. The congregation's call and the magistrates' presentation were then delivered to Mr Scott, who accepted the charge.[50]

Having acted so correctly in 1723 it is surprising that, when Mr Scott died in 1737, the Presbytery wrote to the Earl of Morton to inform him that the charge was vacant and to recommend Mr George Reid, thereby appearing to concede that Morton had a legitimate interest.[51] However, after considerably delays, the magistrates presented the Rev. Edward Irving and, following the precedent of 1723, Morton's representative arrived to make the same presentation. The pantomime whereby the presentation was made, first by the magistrates, and then by the Earl of Morton, was repeated in the appointment of John Scollay (1742), John Yule (1747), James Dunbar (1748) and Hugh Sutherland (1764). Aware of the weakness of his position, Morton never forced the issue by presenting a rival candidate. When Sir Laurence Dundas bought the earldom estate, and thereby acquired whatever rights of patronage Morton had possessed, he followed the old tactics when George Douglas was appointed to the second charge in 1768, but in 1776 when Thomas Traill was appointed, he gave up his claim to patronage and allowed the presentation to be made by the magistrates alone.[52]

If the appointment of the ministers to the two Cathedral charges was usually achieved without much acrimony, the same could hardly be said for other Orkney parishes where from time to time patronage caused bitter

divisions. In Scotland the question of patronage split the national church and caused the hiving off, first of the Seceders (1733) and then of the Relief Church (1761). However, patronage disputes in Orkney were not just a matter of principle, but had a strong political strand to them. Landlords, elders and heritors were already in dispute with the Earl of Morton over the weights and measures he used to uplift skat and feu duty, and so they could stir up trouble for him by resisting his nominees. Morton's support for the House of Hanover and the lingering Jacobite sympathies of many Orkney lairds were further areas of conflict, and it is significant that the most celebrated patronage disputes were all within a year or two of the 1745 Rebellion—the resistance to the ex-Roman Catholic priest, James Tyrie, first in Cross and Burness (1744-6) and then in Sandwick and Stromness (1747),[53] and the popular outcry against the presentation of the Rev. John Reid to Orphir in 1745. Attempting to present an unpopular minister against the wishes of the congregation could result in a riot. When the Presbytery arrived to induct John Reid, it found the church doors locked and an angry crowd of women determined to prevent his entry. Stories circulating in Edinburgh that troops brought in from Caithness had killed one woman and wounded several others are unlikely to be true, but a further nine months seem to have elapsed before John Reid was successfully imposed on his parish.[54]

Not many of the ministers coming up through this system were Orcadian, and those few who were native-born, such as Thomas Baikie, Thomas Traill of Hobbister, and Thomas Traill of Tirlot, belonged to cadet branches of landed families. Several others were second-generation Orcadians, being sons of ministers already settled in other parishes. But in the eighteenth century there was not one single example of an Orkney 'lad of pairts' who worked his way up from humble origins.

Among non-Orcadians—and they formed the great bulk of the clergy—the lad-of-pairts tradition was stronger. It was with some truth that the Rev. Francis Liddell, the half-mad minister of Orphir, described his colleagues as "a troop of poor ragged students from the College of Aberdeen who, after having been shin-burned and smoke-dried for twelve or fourteen years in a country school, are at length introduced

to an Orkney living".[55] An examination of their origins
reveals that the great majority came from north-east or
eastern Scotland. Typically they had a small-town or rural
background; it was very rare for an Orkney minister to have
originated in one of the cities.[56]

 Schoolmastering was often a prelude to the ministry,
and the best of these Orkney schools could provide an
impressive curriculum,[57] but an alternative was service in a
laird's household. Early in the century when Episcopalian
landowners were reluctant to attend Presbyterian worship,
they employed private chaplains and, long after the divisions
between Episcopalians and Presbyterians faded, young
ministers were still engaged to tutor the laird's children. In
other parts of Scotland, and even more so in England, there
was a considerable social gulf between landowners and
clergy, but in Orkney they were on terms of greater
equality. Orkney lairds did not belong to the aristocratic-
landowning tradition which only came to dominate Orkney
in the nineteenth century. They were merchant-lairds,
immersed in trade, and their landed properties were
relatively small. Thus there was no bar to the minister,
having served an apprenticeship in a laird's household and
eventually successfully established in an Orkney parish,
marrying into the tight-knit kindred-network of Orkney's
landed families. In striking contrast to the disputes between
ministers and lairds which characterised the first years of the
century, they had by the end of the century grown together
to the point where their interests and prejudices were
indistinguishable.

 The intricacies of the ministerial-landed network defy

Fig. 1. *The ministerial-landed network*. The family tree of the
Rev. Thomas Baikie, minister of the Cathedral from 1697 to
1740, illustrates how members of the clergy might originate
from cadet branches of landed families. These ties with
merchant-lairds were reinforced by marriage. Incoming
ministers, by making the kind of marriage society expected
of them, instantly achieved a place in the ministerial-landed
network. In the short term the effectiveness of the Church
was greatly strengthened; in the long term the association of
minister and laird led to the growth of dissent.

69

description, but a sample can be found in the three Cathedral ministers, Thomas Baikie, his son-in-law John Yule, and his son Robert Yule, whose ministries covered all but seven years of the 127-year period between 1697 and 1824. Thomas Baikie owed his good fortune in being promoted to such an important charge at such an early age to his sound Presbyterian credentials, at a time when few Orkney ministers were in good standing with the ecclesiastical establishment. But he also owed his advancement to family connection: he was a younger son of James Baikie who had recently acquired a small estate in Sanday; George Traill of Quandale, at that time Provost of Kirkwall, was his brother-in-law; and the all-powerful Baikies of Tankerness were second cousins. Thomas Baikie reinforced these landed connections by his marriages, first to Elizabeth Fea, daughter of Patrick Fea of Whitehall, and second to Elizabeth Traill, a marriage which brought him a myriad of Traill relatives.

Thomas Baikie's family tree (Fig. 1) was a great tree in which migrant ministers with no Orkney connections could find a nest. Ministers arriving in Orkney were generally unmarried; by making the kind of marriage which society expected of them to the daughter either of a minor laird or fellow minister, they instantly achieved a place in the ministerial-landed network and a host of useful relatives. So, in addition to Thomas Baikie's landed relatives who have already been mentioned, he eventually acquired a relationship by marriage to a large number of ministers. The Rev. Alexander Grant of South Ronaldsay was his brother-in-law, Thomas Traill of Lady Parish was his nephew, Hugh Mowat of Evie and Rendall and John Yule were sons-in-law, while his grand-daughter married James Tyrie, the ex-Roman Catholic priest, and his great-grand-daughter married the Rev. George Low of Birsay and Harray. Similarly, the Rev. Robert Yule not only followed his father as Cathedral minister, but two successive ministers in the second charge were respectively his father-in-law and his brother-in-law.

If family connections and social position placed ministers on terms of equality with Orkney's merchant-lairds, so did their stipends, which were generally somewhat above the Scottish average. Since stipends were paid partly in commodities such as malt and barrels of butter,[58] the total value in money terms is partly an estimate. At the end of the eighteenth century the ministers who wrote the *Statistical*

Account valued South Ronaldsay at £85 stg. per annum,[59] the Kirkwall first charge at £80,[60] Holm at £70,[61] Westray at £70,[62] Firth and Stenness at £60,[63] Birsay and Harray at £60,[64] the Kirkwall second charge at £60,[65] Stronsay at £54,[66] and Evie and Rendall at £51.[67] At that date men could expect to earn about £2:10s a year from agricultural work, and women a good deal less.[68] Hence, measured in money terms, the social gulf between the clergy and the bulk of their parishioners was very great. Yet, human nature being what it is, ministers were not necessarily satisfied with what, in Orkney terms, was a very comfortable income, and legal actions to obtain augmentations of stipends were frequent. When the Lord Advocate visited Orphir and was entranced by its scenic beauties, he exclaimed, "Happy is the clergyman who inhabits yonder mansion!" But the clergyman in question had his mind fixed on more mercenary matters when he replied, "And still happier would he be would his Lordship help him to an augmentation of his stipend".[69] Stipends were still paid from the rents of the ancient Bishopric estate, now in the hands of the Crown's tacksmen. It was laid down that payment had to be made from "the first and readiest rents", but in practice there were long delays. Ministers complained that, as a result of ill-will and prejudice, they were put off with "the last and unreadiest".[70]

Life was even more complicated when ministers personally collected the vicarage teinds (tithes), which were paid in small quantities of produce from individual farmers and fishermen. In 1747 the Rev. John Scollay, the minister of the second charge, gave evidence about their collection. The minister could either go round and collect the payments himself as Mr Scollay was then doing, or else the teinds could be set in tack in an arrangement whereby the minister sold the rights to a local merchant and was thereby relieved of the bother of collecting the produce and converting it into money. The total value of Mr Scollay's vicarage teinds was not large, only about £5 stg., but the difficulties of collection were such that the real income was even less. Mr Scollay's scale of charges was as follows:

4 marks of butter (c. 2 kg.) for each cow that had produced a calf
2 marks of butter (c. 1 kg.) for each farrow cow

2 marks of butter (c. 1 kg.) for each "qyiock"
1 mark of butter (c. ½ kg.) for each farrow qyiock
8 pennies scots (⅔rd stg.) for each calf
12 pennies scots (1d stg.) for each lamb, or else every
 tenth lamb
A tenth of the wool crop
4 pennies scots (⅓d stg.) for each "grice" (pig)
A tenth of the eggs
A few geese "as their flocks can allow"[71]

 Although Mr Scollay was not as well off as most of his
ministerial colleagues, there was nevertheless a great gulf
between the minister and the small farmers from whom he
collected these payments. It can hardly have advanced the
cause of religion to have had the minister going around,
spying out the farmer's stock, exacting complicated pay-
ments, and cadging a few geese.
 The complaints of farmers about having to pay teinds
was largely unrecorded, but when the 1698 Commission was
anxious to discredit the Rev. Alexander Pitcairn, "late
pretended Dean", it was ready to listen to complaints about
the harsh manner in which he collected teinds from his
South Ronaldsay parishioners. From the evidence of a host
of witnesses it is clear that the minister's attempts to enforce
these payments in the famine years at the close of the
century was the main cause of his unpopularity. For
example, Robert Bruce gave evidence that he had been due to
pay one mark, and he claimed that he had actually handed
over small fish to that value. This was disputed by Pitcairn
who eventually sent the Church Officer to 'poind' him—to
seize some item of property of equivalent value. The Officer
tried to take possession of the spade with which the witness
had been working, but he would not hand it over.
Eventually the Officer had taken possession of some fishing
lines, and he had stripped the blankets from the bed. Then,
to add insult to injury, Bruce had been compelled to carry
this confiscated property to the manse and, with one thing
and another, he had been kept away from his work for a day
and a half when he ought to have been busy sowing bere.[72]
 The minister could further augment his income if he
cultivated his own glebe. In this respect the Cathedral
ministers were not as well provided as their country
colleagues, and indeed there was no glebe with the second

charge. Originally the minister of the first charge had a good glebe at Glaitness, but by the eighteenth century the glebe was at Quoybanks and was "not worth above £8 stg. yearly, and sometimes let below it."[73] However, country ministers were often knowledgeable farmers, and their *Statistical Accounts* show an acquaintance with techniques of improved farming which at that date had hardly found their way into Orkney. Most accounts have sensible comments about the lack of enclosures, the dangers of grain monoculture and the need for rotations, the mismanagement of common land, the need for draining, the desirability of longer leases, and the advantages of abolishing run-rig.

The improvement of the Shapinsay glebe was one of the earliest ventures in agricultural innovation, pre-dating even Thomas Balfour's improvements at Sound. Prior to 1759 the glebe was run-rig, and consisted of every third rig throughout the entire district of Kirbister which stretched nearly a mile and a half along the southern shore of the island. In that year the Rev. Alexander Pitcairn junior, then newly appointed to Shapinsay, obtained a division of run-rig through legal action in the Sheriff Court.[74] The glebe lands were consolidated into a single block, and Pitcairn created a pattern of rather irregular enclosed fields surrounded by earthen and stone dykes. Even in the early part of the nineteenth century the Shapinsay glebe was still the largest single block of arable land in the entire island.[75]

If the alliance of ministers and landlords did much to produce the "sober, regular and industrious"[76] tenantry so much in evidence at the close of the eighteenth century, the Kirk Session was the instrument by which this was accomplished. Its activities were as diverse as administering poor relief, looking after orphaned children, providing testimonials for servants, caring for shipwrecked seamen, and financing smallpox innoculation,[77] but inevitably attention focuses on the Session as a moral police-force, prepared to devote endless time and patience to investigating sexual irregularities, allegations of slander, and cases of Sabbath breach.

The divisions which existed on the Town Council between merchants and craftsmen were carried over into the Session, and the merchants were the dominant group in terms of number and authority. Taking 1712 as a sample year, none of the elders were quite of the first rank among

merchant-lairds, but four were important enough to be ship-owners.[78] Three of the elders who were merchants were also Bailies of the town, but they never attended the Session unless their presence had been specifically requested when the Session needed to invoke the support of the civil power. Craftsmen were less numerous; they included two litsters, a dyer, a wright or carpenter, and a tailor and, while they might defer to the merchants, they were nevertheless substantial people by Kirkwall standards, all with their own businesses. So there was an obvious class element to the Session's proceedings. Membership consisted of the employers of labour, whereas the most regular defaulters were servant-girls and apprentices. The Session functioned as an extension of social control.

But elders could hardly claim to be morally superior and, since they sat in judgment on others, it is only right that they should be judged by their own censorious standards. Robert Morrison was the Church Treasurer and, when he died, it was discovered that he had embezzled £60 from church funds;[79] both Hugh Clouston[80] and William Traill[81] had previously had to make amends because their wives were pregnant at the time of their marriage, and thirty-seven years later Hugh Clouston was required to make a formal denial of paternity when his pregnant servant-girl was hurriedly shipped off to Caithness in suspicious circumstances.[82]

A typical Session case would arise when one of the ministers or an elder heard gossip that a servant-girl was pregnant. She would receive a verbal summons to present herself before the Session on the following Monday. At its simplest, the girl would admit that she was pregnant and would name the father who was already waiting outside. He would be called in, cheerfully admit his paternity, announce their intended marriage, and express his willingness to pay the monetary 'penalty' on behalf of both the girl and himself. The guilty pair would be sentenced to appear in sackcloth, of which the Cathedral kept a suitable supply, and to stand on 'the white stone' at the time of morning service to receive a public rebuke from the minister. However, the Session operated double standards; for more well-to-do members of society a public appearance could be commuted to a rebuke in the privacy of the Session in return for a suitably large 'penalty'. But William Brodie, in addition to

paying one guinea for himself and Marjorie Esson, volunteered to repair the dial of the clock. Suspended high on the tower in full view of Broad Street, he could hardly have performed a more public penance![83]

When the alleged father denied paternity, matters became much more protracted. The parties were liable to be questioned on several occasions, and the case was referred from Session to Presbytery and back to the Session in the hope that at some stage the truth would come out. One possible tactic was to obtain a child-bed confession. Thus when Barbara Hamiger named William Tait as the father of her expected child and he denied it, the Session decided to defer the matter until she was delivered "when it is likely that in her pangs she will make further acknowledgement, or against, which time the said William may be brought to a more ingenious confession"[84] (they meant 'ingenuous'—an ingenious confession was the last thing they needed). In this case the tactic worked; Barbara continued to name William as father, and he then acknowledged paternity, although what benefits, if any, this brought to their future relationship is not recorded.

However, if a man continued to deny paternity, the ultimate test was the dreadful Oath of Purgation. It was a step not to be taken lightly and, even when the man was willing to take the oath, there were long delays to ensure that he understood the gravity of the step he was about to take. John Garrioch had been named by the vagrant-woman, Isobel Anderson, as father of her child, and early in 1722 he had already been shown the oath he might be required to take when, placing his hand on the head of the child, he would "wish that all the curses of the law and the woes of the gospel should fall upon him" should he swear falsely. In June the Session "dealt with his conscience", and in July both John and Isobel appeared before the congregation when the minister explained the danger of swearing falsely. It was only after further appearances before the Session that John was permitted to take the oath. Mr Baikie preached a special sermon for the occasion from the text "Everyone who tells lies under oath will also be taken away". Then, placing his hand on Isobel's child, John publically stated that neither was he the father nor had he had any carnal dealings with the child's mother.

For the woman the situation became desperate when the

man took this oath. Since the oath was so terrible, and such
care had been taken to administer it, the man was deemed to
have cleared himself beyond all possible doubt, and so it
followed that the woman's claims had been entirely
malicious. The Session now had to decide what was to be
done with Isobel Anderson:

> . . . the Session considering that she is a most wicked
> vile person and that, if some corporal punishment be
> inflicted, she may be brought to confession of another
> father to her child, and having nothing to pay as
> pecunial mulct, was referred to the magistrates, who
> appointed her to be imprisoned in Marwick's hole, the
> common prison for such delinquents . . .

Four days later it was reported that, by order of the
magistrates and the Steward-depute, she had been expelled
from the town by the common hangman.[85]

On most Sabbaths there would be someone on 'the
white stone', and harrowing cases involving the Oath of
Purgation were liable to occur every few years. To the
modern mind the whole business seems prurient and
distasteful in the extreme. However, in the eighteenth
century, besides the issue of morality, there was the purely
practical necessity of ensuring that children were born within
the supporting framework of the family. In 1739 endless
trouble was caused by an infant whose mother was dead and
whose father was unknown; although frequently mentioned
in Session Records, the child's name was never recorded, and
even whether it was male or female is unknown. It was
always referred to simply as "the foundling", and elders
were regularly appointed to take up small collections in their
'quarters' in order that one family and then another could be
paid to look after it.[86]

The Session had its lighter moments, and one such
involved the highly complex ethical question of whether or
not it was lawful to kill whales on Sundays.[87] One Sunday in
October 1721 John Oddy was on his way home to Scapa
after the morning service when he was enraged to discover
that his neighbour, Gilbert Spence, and a number of others
had borrowed his boat without his permission in order to
kill a whale which had become stranded on a sandbank. John
Oddy was already on bad terms with Spence; he burst into

Spence's house and gave him a piece of his mind. "Ye are a knave," he told him, "and if I had you at the back of a dyke I should tell you more of your knavish tricks."

To the present-day way of thinking, the point of issue might seem to have been the borrowing of a boat without the owner's consent. We might also expect an eighteenth-century Session to be concerned about people who broke the Sabbath by killing whales when they should have been attending morning worship. However, the affair came to the Session on neither of these grounds, but as a complaint by Spence that Oddy had slandered him by calling him a 'knave'. 'Knave' was a somewhat stronger term of abuse than we should now consider it to be, but slanders of this kind were common and were treated by the Session with a seriousness which we should now consider quite dispro-portionate to the offence.[88] Witchcraft was on the wane,[89] but there was still a strong belief in the power of the word to hurt. A reputation was something which could be "taken away", rather like the profit of a cow, and if it had been taken away, it ought to be "given back". So a number of witnesses were called who confirmed that Oddy had indeed called Spence "a knave and a villain". Despite the provocation, Oddy was sentenced to appear on the white stone, but he utterly refused to do so. The Session then asked the magistrates to force him to obey church discipline, but Oddy never made his appearance. Perhaps the magis-trates decided that the Session's sentence was a trifle harsh, considering that the whole affair had been precipitated by the unauthorised borrowing of Oddy's boat.

But the Session, having found Oddy guilty of slander, had also to decide whether Spence, by killing a whale, was guilty of Sabbath breach. A whale provided enormous profits from the sale of its oil, chances to capture whales were few, and a normal person could hardly be expected to forego an opportunity. The Session "considering that others in the country did so on like occasions, thought fit before they enquire further into this matter of catching whales as a Sabbath breach, to take advice from the Presbytery".[90] The Presbytery must have advocated leniency, since nothing further was heard of Spence and his whale.

By the end of the century, ministers were figures of great authority in their parishes. Ministries were on average

twice as long as they had been in the previous century, and
many spent a lifetime in a single parish. Distinguished
members of the clergy included George Low, an eminent
naturalist and antiquarian who, in less isolated circumstances,
might have risen to the very first rank in terms of his
scholarship. The Rev. George Barry, minister of the
Kirkwall second charge and subsequently of Shapinsay, was
author of *The History of the Orkney Islands*. Other ministers
like Alexander Pitcairn junior, and the Allisons, father and
son, were in the van of agricultural improvement, while the
Rev. William Clouston's contributions to the *Statistical
Account* reveal an amazing grasp of the minutiae of the
parochial economy. In nearly all cases their qualities of
humanity and compassion shine through their accounts of
their parishes. Their powerful influence had contributed to a
society where crime and violence were almost unknown,
where drunkenness and profanity were rare, and where great
progress was being made towards a universal basic literacy.
The contrasts with the early years of the eighteenth century
are striking.

It was a monolithic society in which, at an organi-
sational level, dissent was unknown. In 1798 there had been
only one Papist in the synod and by 1716 there were none,[92]
although the Rev. John Brand was obviously right when he
noted that a popular attachment to pilgrimages, penances,
votive offerings, the observation of saints' days, the use of
holy water, the habit of signing with the cross, and
veneration for local chapel sites all represented a remarkably
persistent devotion to a degenerate form of Catholicism, long
unsupported by any priesthood.[93] Similarly Episcopalianism
represented a competing tradition within the Church of
Scotland rather than as a separate denomination. Even before
the 1715 rebellion it was fading, and after 1745 the Episcopal
tradition was virtually extinct. The controversies which
fragmented the eighteenth-century Church of Scotland—the
Original Secession, the split with the Relief Church, the
division between Auld Lichts and New Lichts, and between
Burghers and Anti-burghers—entirely bypassed Orkney.
They left not a ripple. As the Cathedral minister, John Yule,
put it, "If we are right, we are all right; and if we are wrong,
we are all wrong."[94] Established ministers took an under-
standable pride in the fact that their parishioners were
"strangers to those vain disputations, violent dissentions, and

strife about words, so frequently met with in other places".[95] When ministers wrote the *Statistical Account* they were still confident of church unity. They showed not the slightest awareness that the defection of large sections of their congregations was imminent, first to the Secession Church, and a generation later to the Free Church.

Yet the danger signals were there. The temper of the times was changing, and people were craving more excitement and emotion than the moral preaching of eighteenth-century Moderates had provided. This was illustrated by the popular response to the Quaker mission of John Pemberton of Philadelphia who visited the islands in 1785 and again in 1786.[96] He was hospitably received by the Orkney clergy, who were confident enough to allow Pemberton to use their own pulpits to preach to a series of crowded meetings. In Kirkwall 1,500 people packed into the Cathedral—never before had such a crowd been seen. Again at the close of the century the Haldanes met with the same response when they swept Orkney in an emotional crusade.[97]

It is the ultimate commentary on the eighteenth-century church in Orkney that two-thirds of its membership was about to defect. However, the attractions of dissent were only partly religious. Ministers and lairds had been a powerful combination, and too closely associated for the good of the established church.

Church discipline had operated as an extension of social control, and was firmly in the hands of 'the people above'. As the eighteenth century drew to a close, the social order in France was overthrown by revolution. People in Orkney recoiled in horror from such excesses; in Stronsay the Rev. John Anderson could congratulate himself that his people still believed in fairies rather than in radical ideas.[98] Nevertheless religious dissent, even in Orkney, was essentially part of the same movement. Dissent was socially acceptable, and it was totally respectable, but at the same time it was a pointed and effective way of dissociating one's self from the natural order of society as it had been constituted in the eighteenth century.

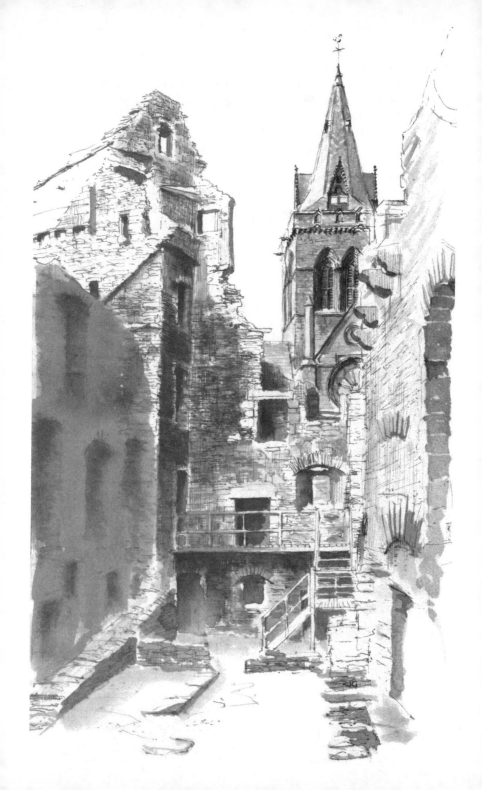

SOME ASPECTS OF THE 19th CENTURY

H. W. M. Cant

M any distinguished people have served as Bishops and Reformed Ministers in St Magnus Cathedral, through its long history of more than 850 years. But few have been better witnesses to Christ and the Gospel than the Rev. Dr William Logie, Minister of the First Charge from 1824 to 1856.

It is of some interesting events in his ministry, along with that of the Rev. Peter Petrie AM, Minister of the Kirkwall Second Charge, that I write in this chapter.

The Rev. Robert Paterson and Established Church Life in Kirkwall circa 1824

At this time in Kirkwall besides the Established Church, the Cathedral—and other churches—there was a United Secession Church. It was to this latter Church that the Rev. Robert Paterson came to be the minister in 1820, when it was reckoned that the number of those attending was about 900. There can be no doubt about the vitality of this congregation, and Mr Paterson (later Dr Paterson) increased the membership, formed Sunday Schools and was instrumental, as his predecessor had been, in founding Secession Churches in Orkney.

Paterson was a powerful missionary preacher, but also a strong controversialist, with not too much love for the Auld Kirk. For example, he vigorously attacked what he felt to be a wrong explanation of the rise in Kirkwall of his own Church. A "zealous friend" of the Established Church had written:

> It is a notorious fact, . . . that it [the Secession Church] arose from the illegal attempt of some turbulent mechanics to deprive one of the Kirk Sessions of their

just dues at the burial of the dead; to their defeat in a
process of law before the Court of Session on the point;
and their subsequent ill-will to the office bearers of a
church which they had unsuccessfully attempted to
injure in her rights.[1]

To this, Paterson replied:

Now, Sir, this miserably constructed, confused, ungram-
matical statement, characterised as a 'notorious fact',
turns out to be a notorious falsehood.[2]

The real origin of the Seceder Church in Kirkwall, he
said, was due to a few pious individuals who, "having their
righteous souls vexed from day to day with the prevailing
corruptions and errors of the Established Church, of which
they were members, formed themselves into 'a meeting for
prayer and Christian conference'."[3]

"At this time religious life in the established Church of
Scotland had sunk to a low ebb."[4] Of its ministers, it could
be said that "they had turned from the cultivation of grace
to the culture of graces, and their influence deadened
spiritual life in those who were affected by it."[4] "It seems
small wonder that under such circumstances many earnest
minded and evangelical men broke away and set up secession
churches, trying to find more spiritual nourishment than the
established church could offer."[4]

This retrospective view of the Established Church in the
early 19th century would have been entirely approved of
by Mr Paterson, who attacked not only the record of that
Church before his time but also in his own day in Kirkwall.

In 1824, Paterson wrote to the *Christian Monitor* — a
monthly periodical of that time under the direction of the
United Secession Church — defending that same Church
against what he regarded as an unfair attack upon it. This
attack had been made, in Paterson's view, not only on the
"Representation" of the case for help for the Secession
Church in Sanday, sent to the *Christian Monotor,* but also
upon the whole Seceder movement in Orkney.

Now the attack had been made by an Orcadian
correspondent to the *Christian Instructor,* a periodical
reflecting more the Established Church viewpoint. Paterson,
in his response, had some very hard things to say about the

Established Church in Orkney during the last half-century prior to his time, when, as he put it:

> the spiritual management of it was left wholly and
> entirely in the hands of the Established Church . . .
> there were some parishes where the ordinance of the
> Lord's Supper was not dispensed for twenty or thirty
> years; and one clergyman is represented as having lived
> and died—and his life was none of the shortest—without
> having dispensed it at all.[5]

The Orkney correspondent had written of these clergy: "with several of them I have the pleasure of an intimate acquaintance, whom I know to be able, pious and zealous men, faithful preachers of the doctrines of grace, and preaching by their lives as well as by their sermons; and I have the best grounds for saying that the clergy of Orkney will, as a body, bear a comparison with the pastors of any Christian Community whatever."[6]

Paterson's response was:

> This is a declaration not only uncalled for, but
> altogether unwarrantable . . . But as it is obviously
> designed to persuade the public that the islands and
> parishes of Orkney are at present in a state of good
> spiritual cultivation, that they are vineyards in which
> labourers from the Secession are unheeded, and that
> they may be left with safety in the hands of the
> Established Church, the immortal interests of thousands
> urgently require the truth to be known.[7]

Further on, Mr Paterson continues, speaking of the Orkney correspondent to the *Christian Instructor:*

> It would have been wiser in this gentleman to have also
> avoided the point of "preaching by their lives as well as
> by their sermons;" for it is really ticklish ground. Here,
> too, I could question him in such a manner as, with all
> his confidence, could scarcely fail to cause the blush of
> shame deeply to suffuse his cheeks. But, for the present,
> I spare him; although, if he persists in his attempts to
> calumniate the Secession, and to disturb her peaceful

operations, I do not promise to be always so
forbearing.[8]

Now the very interesting question here is, who was
"this gentleman" to whom Mr Paterson refers above, and
who obviously took a very different view of the Established
Church. Could it have been the other outstanding Christian
minister in Orkney at this very time, the Rev. William
Logie? He certainly knew all about the situation in Sanday,
for he had just finished a ministry there and had come to be
minister of the Cathedral's First Charge in 1824. But now we
must turn to Logie himself before describing his part in two
interesting events in his ministry, one local to Kirkwall, and
the other national.

William Logie's Early Life

William Logie was born in Kirkwall in 1786 near the
cathedral he so much loved, and in which he was to be
minister of the First Charge for 32 years. His father was a
Kirkwall businessman and a magistrate in the town; his
mother was known for her Christian character. They
educated their son in their own City and Royal Burgh.
Death claimed seven of the family, and only one was spared
to be William's companion in later life. William Logie's son,
in the memorial notice of his father, wrote that:

> the delicate state of his own health concurred with
> these trying dispensations of Providence [the many
> family bereavements] in preserving him from the
> vanities and follies of youth, and infusing into his
> character a settled seriousness and gravity, which the
> natural cheerfulness of his disposition never suffered to
> degenerate into anything approaching austerity and
> gloom.[9]

It was in Edinburgh that he became a divinity student,
and his son recalls having seen among his papers a document
recording his self-dedication to God and the devotion of his
life to the service of the Church, "imploring his Father in
Heaven to accept of him as an humble instrument in His
hands for winning souls to Christ, and to give him grace and
strength to fulfil his vows, and to cleave unto the Lord."[10]

Logie was licensed to preach the Gospel by the Presbytery of Kirkwall in 1809, and preached his first sermon in Shapinsay. He continued to preach with great acceptance in various parishes throughout Orkney, and was soon seen as one of the ablest young ministers:

> He preached to men as sinners, and directed them to the Saviour as their only refuge; he pressed the offers of mercy upon them, with all the earnestness of one who had himself embraced them, and felt their value[11] . . . He never made the message a vehicle for displaying the messenger, nor labelled the food with which he fed his people with a puffing description of the various processes of its manufacture.[12]

In 1811, William Logie was ordained as minister of Lady parish in the island of Sanday, where he remained for almost 14 years. He lived for his people and was a good visitor, "teaching from house to house 'warning every man, and teaching every man in all wisdom that he might present every man perfect in Christ Jesus'."[13] He was married in 1814 to Elizabeth Scarth, daughter of Mr James Scarth of Kirkwall. Six of his children were born in Sanday.

In 1824, following the death of the Rev. Robert Yule, Logie was presented to the First Charge of Kirkwall by both the claimants to the patronage, the Crown and the Town Council. He was apparently reluctant to leave Sanday, but his duty to his rising family tipped the scale. His son makes this strange comment—"Kirkwall, at that time, offered educational advantages, which it has long since ceased to possess."[14]

When William Logie came to Kirkwall, he was faced not only with a collegiate charge, but with three major problems: he had no manse, no parish church, and no parish school. In 1830 his colleague, the Rev. John Dunn, minister of the Second Charge, died, to be succeeded in 1831 by the Rev. Peter Petrie. After 10 years as minister of St Magnus, William Logie was presented in 1834 with a piece of silver plate as a token of the respect and affection of the congregation who saw in him a minister "distinguished not only by his eloquent and masterly expositions of Divine Truth, but by an unremitting zeal and fidelity in the discharge of every pastoral duty."[15]

The Stone and Lime Disruption

This disruption was so called by William Logie because it had to do with the nature of the building of St Magnus Cathedral. The "stone and lime" of the Cathedral failed at this time to keep out the rain and to drive away the damp, so that we read in Hossack's book *Kirkwall in the Orkneys:*

> the disruption movement may be said to have begun in Kirkwall in 1822 as a protest against the discomforts of St Magnus Cathedral as a parish church.[16]

In that year, three of the members of the congregation— Sheriff Peterkin, Robert Pringle, Supervisor, and David Paterson, Master of the Grammar School—petitioned the Presbytery to remedy certain "evils" in relation to St Magnus Cathedral. These included inadequate accommo- dation—1602 were entitled to seats, whereas there was only seating in the Cathedral for 671. A dozen of the largest seats in the main area of the Church were claimed by eight or nine individuals, some of whom apparently never entered the Church door, while an entire gallery was set apart for the use of the magistrates of the Burgh; only one or two were ever to be seen in it. But, besides the seating "evil", there was the immense discomfort of worshipping in such a building:

> . . . the whole of the ground area in St Magnus Church which is occupied as a place of worship is considerably under the level of the ground . . . The rain water enters the roof, and at the top of the walls from the bartizans, notwithstanding every effort to prevent it, so that even the pulpit cannot be kept free from droppings . . . From the nature of the ground around the Cathedral— from the thickness of and constant moisture in the walls—from the massiveness of the pillars and the smallness of the windows, which admit little air and no sunshine into the body of the Kirk—it is in fact as damp, cold and unwholesome as any cellar or icehouse, and is altogether unfit to be occupied as a place of worship.[17]

You might have thought that Kirkwall Presbytery

would have had compassion upon their fellow Christians sitting week by week in their "icehouse", but they did nothing about it. However, in 1832 representation was made to the heritors of St Ola and to the magistrates of Kirkwall that they should provide, in some way or another, better and more adequate accommodation. This representation was signed by both the ministers, Logie and Petrie. The heritors and magistrates remained, however, immoveable.

After also having tried to get the Lords of the Treasury to do something about the above-mentioned "evils" of St Magnus, and having once more failed to get any response, those who belonged to the Established Church in Kirkwall— the two parish ministers, all the elders, several heritors and some 200 people—went back to the Presbytery in 1834, and this time petitioned for permission to erect a new church in Kirkwall in lieu of St Magnus. However, on the same day there was also lodged with the Presbytery a counter-petition by certain of the most powerful heritors, who asked Presbytery to sanction the erection of an *additional* church in Kirkwall or:

> a kind of chapel or supplementary church to St Magnus . . . those who cannot find accommodation good enough in St Magnus would find seat room in this kirk and the parish church would remain for those who prefer it.[18]

The Presbytery unanimously agreed to refer the whole matter to the General Assembly, and they handed it over to the Commission of Assembly which issued the final deliverance:

> The Commission recommend to the Presbytery of Kirkwall to sanction, if they see fit cause, the erection of an additional place of worship, by private contri-bution, in the parish of Kirkwall, and to authorise the performance of divine ordinances therein, provided always that the regular performance of the same is also retained in the parish church of St Magnus; and further recommend the Presbytery to take such steps as they deem meet to secure that the said parish church shall be kept in a state of sufficient repair.[19]

It was soon after this recommendation by the Commission of the General Assembly, and after a Building Committee (1836) and a Management Committee (1839) had been formed for this new additional church, that differences began to be seen to exist between the ministers of the First and Second Charges of St Magnus Cathedral. Logie's views were set out in a letter *To the congregation of the Established Church, Kirkwall* in 1840.

Petrie's view is to be found in a pamphlet called *Narrative respecting the new place of worship lately erected in Kirkwall.*

Logie's view was that:

> though the proposed building was called an additional church, it soon became evident from its *situation* close to St Magnus and its *great size,* that it was not *bona fide* intended for an unaccommodated district or a surplus population, distinct from the flock in the Old Church, but to contain all the people of the Establishment; while worship was to be continued in the Cathedral for no purpose that appeared, but that of keeping up the fallacy on which an application was made to the Church Extension Committee, and a pecuniary aid received from them,—the fallacy, to wit, of Kirkwall being in circumstances to require two churches connected with the Establishment, which no honest man who knows the place will pretend to affirm . . . the Church Extension Fund was intended as a remedy not for the *badness* but for the *smallness* of a parish church. It was never to a *better* church but to *two* churches that I was always opposed, or to the pretence and fiction of two; and of all fictions, those practised in church matters are most to be reprobated.[20]

He thought that the plan to have both ministers heard in each church each Sunday was a nonsense, as the people "would speedily repair to the most commodious and healthy. Would not worship in the other be a mere mockery?[21] He challenged the Church Committee to cooperate with him in procuring an abandonment of the Cathedral, and to get the administration of ordinances transferred to the new church. Then Logie made it clear that he was ready to promote that object.

Mr Petrie, on the other hand, did not seem worried by the thought of having two churches in Kirkwall. "I decidedly approved of the measure [of an additional church], as being in my view the only method now competent for obtaining the requisite amount of available church accommodation."[22] Mr Petrie took the view that an additional church would solve the problem for most people of discomfort and inadequate accommodation in the Cathedral. Further, if Logie did not wish, except on certain conditions, to preach in the New Church, he had no difficulties, and Mr Petrie felt that the sooner the Established Church, St Magnus, was uncollegiated the better. He was completely against making the new church the parish church of Kirkwall, for that would be for the people to have built a church for the heritors, whereas the heritors ought really, if necessary, to build a church for the people.

This whole disagreement with his colleague in St Magnus was very painful for Logie, for he saw that it would lead—as indeed it did—to the division of the congregation, with the majority of them possibly leaving the Cathedral building for the New Church. Logie wrote these words to his people:

> Believe me, Brethren, I abhor the thought of eating the bread of the Church, without doing its work, or of making God's service a sinecure; but if the greater part of you should be induced, by love of novelty or mere considerations of bodily comfort, to forsake my ministry and dissolve the hallowed bonds which have united us for sixteen years, I shall console myself with the assurance, that if honoured by God as the instrument of promoting, by my humble services, the salvation of even one soul among the few that remain, I shall not miss my reward in that day when the Great Chief Shepherd shall appear.[23]

The New Church was called the East Church (not the present East Church) and it was opened in 1841, and in it Logie's colleague, the Rev. Peter Petrie, ministered with the help of an assistant. In the words of Logie's son: "The effect . . . was to draw away from St Magnus all who preferred novelty, or a very small increase of personal comfort to principle and union. It was with sorrow more than with anger that he beheld this breach upon his fold . . ."[24]

The Disruption of 1843

The "Stone and Lime Disruption" prepared Logie for the greater and more permanent disruption to come—the Disruption of 1843. He attended the famous General Assembly of 1843 where he witnessed "with deep regret and disapprobation, the retreat of the seceding party."[25] But Logie apparently returned ready to upbuild the walls of the Auld Kirk in Orkney where, out of a synod consisting of 21 ministers, seven adhered to the Free Church. Fifteen years later, these seven Free Church charges had grown to 14. This defection from the Established Church in Orkney would not appear to have been too serious, but according to Logie's son:

> . . . the great majority of those who remained were either wholly or partially disabled by age and/or infirmity; and in his own Presbytery, Dr Logie was the only man left possessed of bodily and mental vigour equal to the crisis. Thus, the whole public business of the church in the district fell upon his shoulders, in addition to which he voluntarily undertook the whole duties of the Second Charge in Kirkwall, vacated by his colleague.[26]

For the Rev. Peter Petrie had joined the seceders; no longer now a minister of the Established Church, he continued to minister with his seceding flock in the New Church. But it of course still belonged to the Auld Kirk, and had been built in part by a grant of £200 from the Extension Fund of that Church, so he and his people were asked to leave it. Meanwhile repairs were at last under way on the Cathedral, carried out by the Government department who believed that they were the rightful owners of it. To allow the repairs to proceed, Dr Logie and those with him who had continued worshipping in the Cathedral were asked to leave, and they eventually got entrance to the East Church in 1847.

So in August 1847 Logie preached for the last time in St Magnus, though he always hoped he would be able to return to it. Though he lived to see the Cathedral declared to be the Parish Church—the heritors at the Council taking upon themselves the task of upholding its fabric in all time

coming—the first congregation that entered the building after the Crown had given up its claim, having done a great deal of restoration work, was that which attended the minister's funeral in the year 1856.

For 32 years Logie was minister of St Magnus Cathedral, and having read in some details the story of his ministry as minister of the parish, as preacher and pastor to his congregation, as leader in the Presbytery, and as a man of fervent but unostentatious piety, accompanied by a clear intellect and a generous heart, I see in him if not "a model of a parish minister" at least a notable figure of the Established Church in the 19th century, and recognised to be so not only in Orkney, but also by the National Church of his day. As one of Dr Logie's successors in the historic charge of St Magnus, I find in him inspiration and illumination even for such a time as this.

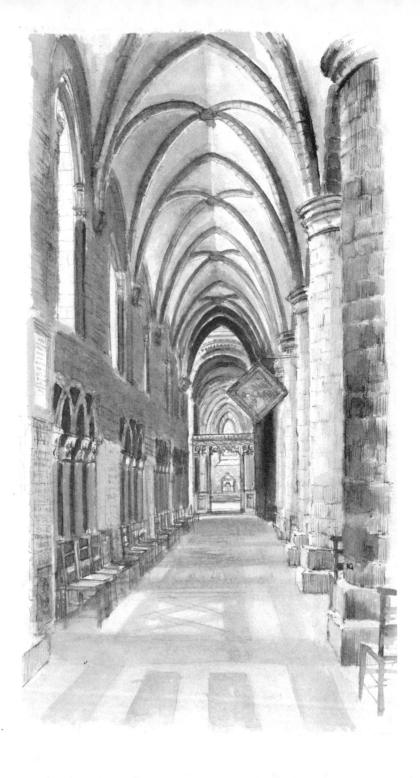

THE CHURCH IN THE POST-PERMISSIVE AGE

Ronald Ferguson

I would like first of all to thank Orkney Islands Council, and the Minister and Kirk Session of St Magnus, for the kind invitation to come to St Magnus Cathedral to give this talk. I bring greetings from another ancient Cathedral—Iona Abbey. I have come straight from the Easter celebrations on Iona—sharing them with people of many denominations from all over the world.

It is a pleasure to visit Orkney again. I have long been an admirer of the writings of George Mackay Brown, and wanted to come to Orkney for some time. I came with my family last summer, and despite spending a good part of the journey hanging over the rails of the St Ola, we had a marvellous time!

'The Church in the Post-Permissive Age' is rather a pretentious title. I am neither a prophet nor the son of a prophet. I have no access to special revelations. I'm simply reporting from the battle-front, having spent 8 years in the huge Glasgow housing scheme of Easterhouse, and a similar length of time with the Iona Community. In Easterhouse, the traditional church structures and expectations had largely collapsed. On Iona, I've been meeting people every other week, who've come from many different parts of Scotland, and indeed many different parts of the world. I've listened to their stories and their struggles, and it's been an education for me.

I want to begin with two stories. The first is one told by Spike Milligan. It's about a man who was on the top deck of a double-decker bus. Suddenly, he heard the sound of singing, and assumed that one of the passengers was responsible. When the top deck emptied, he discovered that the singing was still going on, and that it was coming from himself! Closer examination revealed that the voice came from his own right foot. He was very embarrassed as more

people came on the bus. What should he do? He decided to tie his bootlace tighter—but all that happened was that the voice became falsetto. He rushed downstairs, past the driver, his right foot still singing all the while. His troubles were not over, however. His right foot kept singing as he rushed along the street, past startled pedestrians. He had to mime the words to make it seem as if he was singing normally, and eventually reached home a nervous wreck.

As the days went by, he began to realise the potential of his new discovery. His right foot made a hit record and went on tour. To cut a long story short, the man eventually shot his right foot at a press conference in a fit of jealousy!

The story is a delightful parable of the Kingdom of God. You see, the Kingdom of God is not something we *build*. It's something we *receive*. It's the kind of arena where your right foot bursts out singing Alleluias, and you've no control over it. Or at least if you try to control it for your own use, you end up shooting yourself in the foot. There are no blueprints for the Kingdom of God. It's a gift, something we discover, we stumble upon. The Spirit blows where He wills. So any attempt to prophesy the future is fraught with danger. God still has a few surprises left.

The second story is true—it's about my father. He died about a year ago. He lived in the same town—Cowden-beath—all his life. It was a mining town. Nearly everybody worked in the mines, or in work associated with the mining industry. There was a common sense of values, and a common sense of history, and a common sense of sharing.

My father left school at 13 to work as a painter and decorator. He worked in the same job, with the family firm, all his life. He lived in the same Council house for more than fifty years. He was married to the same woman—my mother—all his life. He lived through two world wars. He worshipped in the same kirk all his life—and that church played an important part in the community. Even when I was a boy, lots of men went to worship—I can still remember the psalm-singing. My father wouldn't become an elder—he didn't think he was good enough. He died, aged 82, in his own bed, in his own home town.

I tell you that, because that era is now over. And the Church cannot pretend that it is still ministering in that era.

Compare that with the reality for young people today. I think about my own children. The situation in Orkney may

be vastly different, but I can only report on what I know. The chances of a young boy working in the same job all his life are slight. The big question is whether he will have a job at all. The prospects of living in the same community all his life—and again, it may be different in Orkney—are not great. I'm not saying it's necessarily a good thing that he should live in the same community, but the chances are that that option won't be open to him. It will be a scramble for jobs, where they can be found.

And what about cultural assumptions? Well, 'Dallas' is everywhere, right in your living-room, whether you live in Cowdenbeath or London, or Glasgow or New York or Kirkwall. In one sense, television broadens the mind, shows us new horizons. In another, it rots our brains and erodes our community life. The distinctive sense of community goes; I'll bet it's happening in Orkney. I don't think it's a plot, but it's insidious and all-pervasive. We're being overtaken by a mass culture. I went back to Cowdenbeath recently, and went to the local football match. The youngsters were singing football songs they had heard on television, and were wearing the same kind of gear supporters wear everywhere now. The sense of it being a distinctive community with distinctive values has largely collapsed.

And what are the chances of someone being married to the same person all their lives? Less than 1 in 3, according to the statistics. And the figures are accelerating towards 1 in 2.

What about wars and the chances of surviving them? My father knew he had a very good chance of surviving two world wars. Now young people know that that particular game is up. The next world war is for keeps.

And what about the Church? The numbers in many places are dwindling, and the Church no longer holds the same place in society that it did. Christianity is very much a minority pursuit, even eccentric in some places.

There is a crisis of jobs, culture, relationships, values, meaning. We live in the midst of a whirlwind, when many of the old landmarks are gone. I am reminded of the Easter litany, "They have taken away my Lord, and I know not where they have laid Him." Many feel a sense of desolation as they try to find their bearings today.

The label we apply to the kind of society that has replaced the old one is 'the permissive society'. Like all

shorthand labels, it's simplistic and misleading. What it means is that the old authorities are gone, and that people are on their own. They can do their own thing. Usually when we talk about 'the permissive society' we are thinking about sexual ethics—freedom of sexual behaviour and consequent instability in relationships.

All this is now being called into question by the AIDS virus which is striking fear into the modern age. Predictably some people have jumped right in to say confidently that AIDS is the judgment of God. Others have said the opposite. I think we need to be very cautious here, and to avoid presumption. If AIDS is God's judgment, he must be a strange God—killing innocent children to get at some people. But what we certainly do need to say is that certain kinds of lifestyle carry certain consequences. There is always a price-tag.

But permissiveness is not just about sexual freedom, and abortion used as a form of birth control, and instability of relationships. For instance, it's about the greedy cult of money which is so much in evidence today. Look at the business pages of the newspapers. There is evidence of ruthlessness. Acquiring vast sums of money is a virtue. Broken promises and dubious dealings are part of the permissive society. Look at the Guinness affair. The big sin is to be Found Out. Wealth and power are flaunted brazenly. The wealthy get wealthier and the poor get poorer. Paintings go for 25 million dollars while millions starve. That's permissiveness at its worst.

The cracks in the foundations of the permissive society are appearing. The smell of death is around. We are seeing evidence of a spiritual bankruptcy. In this vacuum, the people who are kings are the media specialists and the marketing men and the fast-buck merchants and the pornographers and the arms traders and the drug dealers.

What will happen when it collapses (if the Bomb doesn't get us first)? We would be foolish to imagine that people will come flocking back to the Church as it is. They surely won't.

Some people think that when the permissive society begins to collapse, people will repent and come back to church—that all we need to do is to hold on, then to say "I told you so." The reaction which comes—and there certainly will be one—may indeed favour totalitarian religion and

politics, driving out one set of demons and replacing them with another. The electronic church, the creepy TV religious salesmen with the welded-on smiles, and the cults peddling instant salvation may make all the running.

There's no point in yearning for the old days. To replace the permissive society with a new form of authoritarianism would be a disaster. One also has to say that the permissive society is not all bad. There's a sense in which God himself is in favour of a kind of permissive society. That is, He *permits* men and women to make decisions about their own lives, and to make mistakes. He wants us to take responsibility for our own lives. At the crisis hour He sent Jesus Christ to humankind, and permitted men to do what they wished to Him. God wants us to have our freedom, but to use it in love and responsibility.

On the plus side, the permissive society has brought more honesty into personal relationships. People are no longer prepared to simply grit their teeth and endure horrific relationships. Women are no longer prepared to accept a role dictated for them by men. Let us not, in our disgust over some of the exploitative things that are happening today, become nostalgic about the past and pretend that everything used to be much better. Going back to some kind of authoritarian set-up is not God's way. He wants us to go forward to something new.

No. We are called to be a new kind of Church: not yesterday's church ministering to today's world, wishing it were yesterday's world. That doesn't mean we've to be a trendy church—it's not about pop tunes and guitars and gimmicks and public relations. That's as useless as authoritarian religion.

What kind of Church, then, for the post-permissive age?

My experience on Iona tells me that the greatest crisis of our time is the crisis of *meaning*. It underlines all the other crises. And the Church, above all bodies, is equipped to deal with the question of meaning, provided it *lives* the meaning.

Christianity has this conviction at its core: that at the heart of this strange old world, there is a red-blooded personal Love that will not let us go, ever.

The open secret at the heart of the Church's life is that life is ultimately personal, that Life is ultimately Love, that we are not simply numbers, that in God's eyes we are never

redundant, that we are always, always precious in His sight. Each one of us. We live in responsibility and freedom, because God loves us. The kind of permissive society God wants is summed up in the words of St Augustine: "Love God, and do what you like." The secret lies in the first two words. The heart of our freedom lies in the Easter text of St Paul:

"We are buried therefore with Him by baptism into death, so that as Christ was raised from the dead by the glory of the Father, we too might walk in newness of life. For if we have been united with Him in a death like His, we shall certainly be united with Him in a resurrection like His. We know that our old self was crucified with Him so that the sinful body might be destroyed, and we might no longer be enslaved to sin. For He who died is free from sin. But if we have died with Christ, we believe that we shall also live with Him."

That is the heart of the matter, and the true beginning of the Christian revolution. In it, we discover that we are made for God, that He loves us more than any human parent can love us, and that he wants us to be whole.

We can see the flags of a new dawn. The old scientific confidence is crumbling, and the new physics speaks a language which is not unlike that of mysticism. Reverence in the face of mystery is 'in' again. A new consciousness is gradually, slowly emerging.

Scientists are trying to find new models for describing life—and they are using language which is not far off that of the mystics. Indeed when the writings of some modern physicists were set alongside some writings by mystics recently, and experts in both fields were invited to say which was which, they found difficulty in deciding. The Church needs to be part of this struggle for the birth of a New thing.

So what kind of Church for the post-permissive age?

Surely a Church which lives close to Jesus Christ the servant one. Surely a Church which doesn't lecture the nation. Surely a Church which laughs at itself. Surely a Church which doesn't try to lord it over other people. Surely a Church which opens its doors and its heart to everyone. Surely a Church which repents of its own failure rather than judging other people.

We need a Church which will declare that the personal and the corporate are all part of a piece. That prayer and

politics belong together. That the evangelical and the social can't be separated.

When I was a student at theological college, you could tell the evangelicals and the liberals by their style of dress, and by their vocabulary. Now it's all shaken up. Evangelicals are concerned about social and political matters, and radicals are learning to pray again. The Church is learning to reject the false alternatives, and it's very exciting.

We also need to say that charity is not enough. When I was in Calcutta two years ago, I saw a young Indian man pulling people on a rickshaw. My host said he would die young because of the weights he was pulling. I saw the work of Mother Theresa in the streets of Calcutta. Charity is beautiful, but it is not enough. Unless we do something to change the arrangements in the world, young men will still die pulling rickshaws, and people will die in the gutters of the Calcuttas of the world for evermore. The Church has the power to be an enormous force for good, to speak out and to act on behalf of the poor of the world.

Sexual exploitation is sinful. So is financial exploitation. The Church which speaks out about personal morality must also tackle the political systems which keep people enslaved. The Church which criticises sexual failure must also deal with a system in which those who are in work get wealthier and wealthier, while the increasing army of the redundant become poorer and more despairing. The church which pronounces about abortion must also speak out about the slaughter of the innocents involved in the madness of the nuclear arms race.

And surely we must have a Church which is truly ecumenical. How can we go on and on talking to young people about how the Gospel unites and heals, when different parts of the Church are fighting with each other? How we need this healing, particularly in the west of Scotland.

And how we need a healing Church! Many people come to Iona seeking healing—every Tuesday we have a service of prayers for the sick, and the laying on of hands. The healing we need is the healing of the total person—body, mind and spirit.

I began by saying that we can't make blueprints of the Kingdom, that it's not something we build. But we have to prepare, to wait, to make ready. God may entirely surprise

us with a New thing.

I believe that there is hope, not if we pretend that we can keep going on as we are, breathing a sigh of relief when the permissive society collapses eventually—but if we are open to the Spirit of the Living God.

And I believe that God is raising up new signs. Some of them are in religious communities—Taize . . . Corrymeela . . . Iona. When I left Iona yesterday, Easter Monday, work was starting on the building of a new international centre for young people, to be called the MacLeod Centre. It is a sign of commitment to the future.

This historic church of St Magnus speaks to us of eternal things, of a faith which is rooted deep in history. It also speaks to us of new beginnings. This Easter time reminds us that out of the tombs of despair comes the Lord of Life who offers what every age, permissive or otherwise, really needs—the life abundant.

THE TWENTIETH CENTURY
Harald Mooney

M y earliest memory of St Magnus Cathedral dates from
as far back as 1911, possibly even 1910. I sat in the
gallery which provided part of the seating in the choir. We
had risen for a hymn, and my mother whispered to ask if I
wanted to stand on the seat. I said "no", but my mother was
already lifting me up, but I slid down, and seemed to make
an enormous noise. Probably nobody else noticed it, as few
people sat in the gallery. A small boy saw little of the
congregation that sat below.

At that level we had a nearer view of a row of four
carved heads high on the opposite wall. They were somehow
connected in my mind with the line in a hymn, "Ye fearful
saints, fresh courage take", for the meaning I gave to the
word 'fearful' was 'frightening' or 'terrible'.

With regard to that gallery, a front pew was sometimes
occupied by the Provost and Councillors of the town during
a 'kirking' of the Town Council.

I once saw that gallery with every seat occupied. It was
during the 1914-18 War. Three prominent ministers of the
Church of Scotland came from Edinburgh, I think it was to
visit the Fleet at Scapa Flow. Rev. Norman MacLean of St
Cuthbert's, Edinburgh, conducted the morning service. Dr
Fisher, his colleague in St Cuthbert's, addressed the Sunday
School in the afternoon. It was at an evening service that
every seat in the Cathedral was occupied, and the preacher
was Dr Wallace Williamson of St Giles Cathedral. Evening
services were not usual in the three Presbyterian churches of
the town at that time, so members of other churches were
free to attend. The gallery extended across a considerable
part of the north side of the choir.

I remember walking home from morning service with
members of the family and visitors on the first Sunday in
August 1914, when we paused to read a telegram in the
window of one of the local newspapers, which announced
'Britain's ultimatum to Germany'. That is how important

items of news reached us on a Sunday in those days.

As far as the building is concerned, there have been great changes during the present century. When the century opened the congregation worshipped in the choir, as had been the custom since the Reformation. Partitions of wood and glass separated the choir from the rest of the building. The nave and transepts had then a floor of stone slabs. There were three stained glass windows in the nave. There were also in the nave the two memorials to explorers which have been removed to the east end of the choir. A few old relics were enclosed in part of the south transept.

After the death of Sheriff George Hunter McThomas Thoms, it became known that he had made a bequest of £60,000 for the renovation of the Cathedral. This was a source of great joy to a great many people. Some of his relatives contested the will on the ground that his well-known eccentricities proved him to have been of unsound mind, but their plea was rejected. Understanding the situation about the ownership of the building, he had made his bequest to the Provost and magistrates of Kirkwall on behalf of the community.

The question of the ownership of the building had been raised in the middle of the 19th century after renovation had been carried out by a government department which evicted the congregation. Then it was established that ownership was vested in the community of Kirkwall, represented by the magistrates. Here it may be mentioned that the question of ownership was raised again as a result of the Church of Scotland Property and Endowment Act of 1921, when St Magnus Cathedral was included in a list of churches which were to be transferred to the newly-formed General Trustees of the Church of Scotland; but this was contested by the Town Council. Once again it was confirmed by the highest authority in the land that the Cathedral belonged to the town of Kirkwall.

After plans for renovation had been submitted, Mr George Mackie Watson of Edinburgh was chosen as architect. I do not remember much about early stages of the work, but I do remember an afternoon in the early summer of 1914 when our teacher took the class outside in order that we might watch the weathercock being taken down from the mid-19th century spire. I also remember that for some years the Kirk Green was disfigured by a hoarding which

surrounded the area in which stonemasons worked. After the bells were removed from the tower, one of them was housed in a wooden tower in the churchyard.

The outbreak of war did not put a stop to the work of restoration. At first the transepts were still open for access to the choir. If I remember correctly, we afterwards used a south door of the choir.

The choir as we then knew it contained the furnishings which dated from the mid-19th century and were quite undistinguished. A gallery with carved panels which had been erected by Bishop Grahame in the 17th century had been removed and the carved panels had gone to Graemes-hall in Holm; other woodwork bearing the name of Bishop Grahame was later erected in St Olaf's Episcopal Church. Whitewash had been used on walls and pillars. (I do not know when that was first applied.) There was also pink and ochre wash around the arches. But at least the building had been saved in its entirety.

It was in 1918 that we first met as a congregation in the nave. Nearly all the windows had been filled with stained glass. The only new furnishing at first consisted of chairs. The choir was still screened off in order that renovation might begin there. The hour of the second service was changed from afternoon to evening. For the first time in living memory the offerings were gathered by elders who went round the congregation. (The introduction of envelope offerings required a return to use of the large old offering plates.) But apart from the chairs, we had to wait for the carving of the new pulpit and communion table before new furnishings were available.

Meanwhile much patient clearing had to be done in the choir before the colour of freestone that had been so long hidden was revealed. The wooden floor was removed, revealing three different levels leading up to what had been the site of the high altar.

Dr Craven, retired rector of the Episcopal Church, recorded that on a visit to the Cathedral while work was going on, he asked a workman if there had been any interesting finds. The man answered, "Only the coins," but refused to say anything more. As far as I know, that is an unsolved mystery.

One important discovery was made in 1919. A workman

noticed a loose stone in one of the pillars of the choir. When it was taken away, a cavity was seen to contain a box, and in the box the greater part of a skeleton. These bones were examined by a professor of anatomy from Aberdeen, and he was able to state that the condition of the skull corresponded with the story in *Orkneyinga Saga* of how St Magnus was killed. The story of the finding of bones in a similar cavity in the corresponding pillar at the north side was recalled. This had taken place in the 18th century. There is no reason to doubt that the relics of St Rognvald and St Magnus had both now been found.

The new floor of the choir was covered with mostly glazed tiles. For some years this was unacceptable to many people. As far as I am aware, these complaints have died down. Justification for the use of tiles lies in the fact that a number were discovered from time to time in the choir, obviously dating from the medieval period.

Another matter of controversy was the most suitable situation for a pipe organ, which was to be introduced for the first time after the Reformation. The organist of Glasgow Cathedral was chosen to give advice. One suggestion was that it should be placed in the north transept, another that it should be near the west door. Objection made to a position in the middle of the choir was that it prevented a 'high altar' situation for the communion table, and that it came in the way of a clear view of the splendid east window. However, after a new screen was erected in front of the organ it provided a suitable background to the communion table.

When, more than 20 years ago, the east end of the choir was designated St Rognvald Chapel, it was furnished with pulpit, communion table and lectern. These were designed by a native of Kirkwall, Dr Stanley Cursiter, Queen's Limner in Scotland, and executed by a Kirkwall craftsman, Reynold Eunson. These furnishings incorporated old woodwork preserved in the Cathedral.

A new modern window designed by Mr Crear McCartney is to go in the west window this year. This is a memorial window, for unveiling by Her Majesty the Queen during the morning service on Sunday, 9th August 1987.

When I was a boy, the congregation here had two ministers—of the first charge and second charge respectively. There could be an unhappy situation when there was a clash of temperaments. Mr Rutherford had held the first charge

since 1884. Mr Craig had come to the second charge in 1905. I am afraid Mr Rutherford made no favourable impression upon me. I could listen, at least some of the time, to Mr Craig. He was absent for about a year as a chaplain in France during the 1914-18 War. During part of his absence we had a locum called William Barclay. As far as I know, he was the first to introduce into the morning service a talk to boys and girls.

After Mr Barclay left, he completed his university course and served as a combatant in France. While he was there he received a letter from the congregation asking him to consider accepting the second charge of the Cathedral, now vacant owing to the departure of Mr Craig for a parish in Fife. When Mr Barclay became available he was inducted to the second charge. Before long Mr Rutherford retired and the two charges were united.

From the beginning of the century, St Magnus Congregation and its organisations had the benefit of a church hall. It came to be used for the Sunday School and Bible Class, and for a strong branch of the Woman's Guild. Two faithful supporters of the Guild were daughters of a previous minister of the second charge, Rev. James Walker. His son George was minister of one of the largest congregations in Aberdeen. The funds raised by the Woman's Guild helped the congregation to contribute to the various branches of Church of Scotland work in this country and elsewhere. Their meetings provided, and do provide, many happy gatherings.

When I was a boy, sitting in the gallery, I did not see choir or organist. But when we moved to the nave I was much more aware of them. Occasionally they sang anthems, or were joined by a visiting singer. But in more recent times, I think we can say, from the coming of Norman Mitchell—and more recently David Drinkell and now Robin Cheer—as organist, we have seen a great advance. What a delight it is, and what an inspiration, to have the praise led by such excellent organists and such a large and well-trained choir. It is appropriate to have a robed choir. In addition we have here a centre for the annual St Magnus Festival.

Of the ministers who have served the congregations since the days of Messrs Rutherford and Craig, I have known best Messrs Barclay, Rose and Cant.

Mr Fryer served as a chaplain in the 1939-45 War, so

that I was not often in his company. The others all had a sense of humour and were agreeable companions. Mr Barclay was proud of the fact that two men prepared for the ministry in his time. He had the satisfaction of being invited to preach at the octocentenary service after he had left Kirkwall for a church in Glasgow. When he was about to give up his charge here, he said of the building: "Its very dust is dear to me."

The minister after Mr Fryer was Rev. John M. Rose. We were fellow-students at Edinburgh University, so he was no stranger to me. He had been a minister in Scotland and then gone as missionary to Africa. He served as a chaplain in the east when war broke out, and endured many hardships. He afterwards served a church in Edinburgh, before coming to Kirkwall. Coming back to Orkney after a visit to Edinburgh, I passed on to a young lady the message that Mr Rose sent his best wishes. She replied, "You've made my day." Hers was one of the families where his visits in time of illness had been greatly appreciated.

Mr Cant was called to Kirkwall from a church in Leith. Like his predecessors he has a deep love for the Cathedral. I admire the way in which he has a mind that is open to new ideas, and the way in which he is prepared to experiment and undertake new responsibility, as in the introduction of a second morning service. Women elders have taken their place in the Kirk Session.

During the ministry of John Rose the Society of Friends of St Magnus was formed. It was becoming obvious that the sum set apart by the Thoms Trustees to invest for future repairs was quite inadequate to meet present costs. The Society was formed in order to raise money. Then a warning was given by an architect in 1971 that the west end of the nave was in danger of collapsing. Ominous cracks had appeared. A new committee was formed. We were honoured to have the patronage of Her Majesty the Queen Mother, who continues as Royal Patron of the Society of Friends of St Magnus. She has accepted every invitation to visit the Cathedral. Architects have visited Kirkwall to advise: the first was Mr Alexander Heward of Glasgow, and the present one is Mr Richard Carr-Archer of York, who succeeded Mr Michael Mennim from the same city. Now there is a local resident working as a stonemason on the Cathedral, with an assistant. Colonel Macrae of Grindelay, Orphir, has given

notable service in encouraging this work.

The story of the Cathedral includes the story of the congregation. We have reason to be grateful to those who have served as elders and Session Clerks of the Cathedral, especially to the late Colonel R. J. Bond who did outstanding work in the 850th Anniversary Year. During this century there has been a good relationship between the congregation and Kirkwall Town Council and afterwards Orkney Islands Council. We have reason to be grateful to the present Convener, Mr Edwin Eunson. How different this is from the niggling attitude of the Town Council during the 19th century when the Council questioned the right of a church organisation to use the south transept chapel.

I can only briefly refer to our happy relationship with Mr Whiteford, recently minister of Shapinsay, who was associate minister of St Magnus.

There are people here who have been more closely associated with the life of this congregation than I have. I can only apologise for what they will recognise as notable omissions.

I close with this memory. A few years before 1920, a relation of our family had been at an afternoon communion, and told of the well-known elder, Dr Logie, and how his daughter had held the cup to his lips. Dr Logie died at the age of 100. He was a son of Rev. Dr Logie, minister of the first charge, who died in 1856.

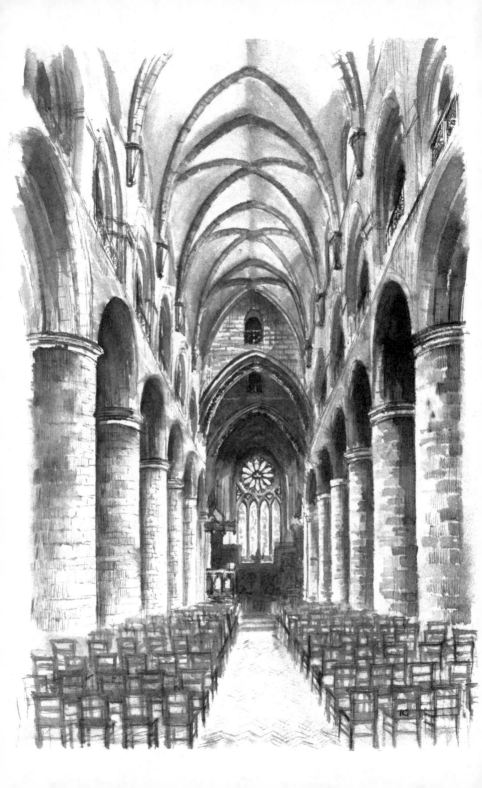

THE TASK OF THE CHURCH IN TODAY'S WORLD

Robert Craig

My first duty is one which is both official and personal, to bring greetings on behalf of the General Assembly of the Church of Scotland and its congregation to St Magnus Cathedral, its minister and members, and to the people of Orkney on this great occasion of the 850th anniversary of the Church in which we sit this evening. I cannot claim that my links with Orkney are numerous: I think I've known only two Orcadians.

In the early 1940s I knew Edwin Muir and Willa in St Andrews, and in the early 1930s I met Eric Linklater, who was the Scottish Nationalist candidate in a very curious by-election in East Fife in 1933, which Mr Linklater was later to immortalise in *Magnus Merriman*. I had the great good fortune last night to meet Mrs Linklater at tea after the lecture here and to hear her recollection of that by-election; it was just as vivid as mine.

I met these two great Orcadians whose memory is bright in my recollection still today, and then one of the first things I did when I was elected Moderator last year was to come up on the invitation of the Reverend Graham Monteith to assist him in the churches in his parish of the South Isles, and particularly in the rededication of St Columba's Church. It was then I got the invitation from your minister, Bill Cant, whom I knew on another island, Iona, nearly 40 years ago. I accepted with great alacrity, and I'm happy that my Moderatorship has been blessed in that I've been privileged to have these two visits to this place.

I have been given the subject on which I'm expected to speak this evening, the task of the Church in today's world. One might answer that categorically and succinctly and say that the task of today's Church in today's world is the task that has always been the Church's task in every day, in every

generation, which is to preach in word and in action the good news of God revealed in the life and teaching of Jesus Christ the Son of God. The Church thus witnesses to the truth that God was and is in Christ reconciling to Himself the world, that is, the cosmos and all that the cosmos contains.

All Christian witness and work in the world flow from its source in the recognition of God for what He is. As our reformed forefathers were wont to express it when they asked the question "What is the chief end of man?" and gave the answer: "Man's chief end is to glorify God and to enjoy Him forever."

All Christian work and witness come from worship of God in Christ, worship such as continued unbroken in this House of God, in which we sit tonight, for eight and a half centuries. As we sit here we cannot but be aware that we are surrounded by a great cloud of witnesses, of men, women and children, known and unknown, gentle and simple, into whose labours you and I have entered, for whom we now give thanks to God. In this place the bush burned and was not consumed, the flame of faith in God flickering fitfully at times and again burning brightly. That is the faith which is the sole source of all true Christian work and witness, as the Church of Scotland and the Christian Churches of the world face our task in the world of today and tomorrow.

My thesis in this lecture is that the Church witnesses only when it takes with the utmost seriousness events both inside and outside the Church, events outside that we commonly call secular. Only if we take with the utmost seriousness the events, the forces, which shape the lives of our fellow citizens of this country and the world, only then is Christ honoured and obeyed. Christ is not enclosed within the bounds or buildings of any Church; Christ is for all the world and all that the world contains, and the world is for Christ.

Through its members the Church will prepare for tomorrow if its members work and witness in the world today. For convenience sake, and rather in the sense of something almost in shorthand, I am going in this lecture to use for those affairs commonly regarded as being outside the Church's provenance the one word "politics" as a synonym for that involvement in public affairs, local and national and international, which I believe to be an essential part of the

witness and work of the Church today.

One of my teachers in New York, Paul Tillich, writes that "religion is ultimate concern; it is the state of being grasped by something unconditional, holy, absolute. As such, it gives meaning, seriousness and depth to all cultures."

"Religion," he concludes, "is the substance of culture, and culture is the form of religion." Once asked in a seminar, "What is the proof of the fallenness of the world?" he said: "Religion itself," by which he meant the fact that there is a religious culture separated from a secular culture, the Church separated from the State, the temple separated from the town hall, the Lord's Supper from the daily supper, prayer separated from work, meditation from research. This duality cannot be fully overcome in human history, for the Kingdom of God can never come fully and finally as part of the present historical process; but it makes a great difference whether the duality is deepened into a bridgeless gap, or whether the duality is accepted as something which ought not to be and which, at least fragmentarily though significantly, can be overcome in this life.

One aspect of that duality which marks for the Christian the fallenness of life in the here and now is our subject this evening. How in the Christian view is that ultimate unconditional absolute concern which is religion related to politics? How is the sense of the holy, the numinous and the sacred, which we experience in this House of God tonight, to be related to the outside world of social relations, of government, commerce and finance? How for the Christian are the ultimate insights of religion to be related to the proximate issues of political existence?

Edmund Burke in his work *Reflections on the Revolution in France* observes that "politics and the pulpit are terms that have little agreement," and he goes on to say: "No sound ought to be heard in the Church but the healing voice of Christian charity. Surely," he says, "the Church is a place where one day's truce ought to be allowed to the dissensions and animosities of mankind."

With these laudable sentiments we may be in general agreement, but I propose to argue that Christian charity is directly relevant to politics, from which it must not be separated; to argue that politics can be understood only in the light of that ultimate human concern of which the Christian religion is one manifestation. I attempt an

exposition and a defence of the Christian involvement in the affairs of the world as it works and witnesses for God in Christ.

One of the conclusions which I submit to you is that Christians are called upon by their faith to active involvement in the affairs of the world for which I am, conveniently, and I hope reasonably, using the shorthand term "politics". There are exceptions to what I think is the general rule, for instance there are cases of special Christian vocation, such as we find in the contemplative orders of some Christian Churches, and there are missionaries in isolated parts of the world, working beyond the confines of political society as usually understood.

A further conclusion is that normally, the structure of politics being such as it is in contemporary society, effective Christian political action will involve membership of a political party.

Thirdly, it must be noted that however distinctive Christian political witness may be, the Christian should be ready to discover what he holds in common with others, perhaps agnostics, atheists, humanists or rationalists, others who do not share his religious presuppositions. The Christian in public affairs may find himself in the strange company of, for example, those who are guided not by the truths of religion, but by reason and justice.

Fourthly, it will be seen that the Christian, though making his utmost effort to act politically by the light of his faith, must be quick to recognise the finite, partial, and self-centred, that is to say sinful, quality of even our most honest political judgments. Politics can be understood only in the light of its theological dimension, but this fact in no way confers political omniscience—and much less political omnipotence—on the Christian, whose views may be much less valid than those of his secular fellow citizens.

We should regard, I think, with some scepticism those Christians who claim to communicate on the hot line, so to speak, with the deity. To attach the name of God to political action is in no way its infallible guarantee. On the contrary, the Christian faith, fortified by its teaching concerning Original Sin, tells us that man is often most sinful when he is most religious. The Christian religion teaches that God made man in His own image, and someone has said that man has hastened to return the compliment, making God in

man's image, by presuming to speak for God, by deifying his own interests in the form of the self, family, class, community and nation.

Christians are committed in their witness to active interest in politics by two particular facts of our faith—the nature and claims of Christian love and the Christian view of the significance of history and world process.

In the thirteenth chapter of St John's Gospel Jesus says: "A new commandment I give unto you, that you love one another even as I have loved you, that you also love one another." If Christians were really converted to Christ, if we had in our lives sufficient of that love of which St Paul in the thirteenth chapter of First Corinthians sees as the supreme Christian virtue and the mainspring of the Christian life, then our active Christian political witness would be clear and effective. For love is on the level of this life, caring for people, mediating to them, in deed and in word, that love which according to Jesus is a fundamental character of God the Father.

An Anglican bishop, Charles Gore, once said that Christian charity meant reading statistics with compassion; and to that, if a Presbyterian may presume to improve on what an Anglican bishop has said, I would add: "and with imagination." Had the Christian sufficient charity in the New Testament sense, that is of self-sacrificial love, he would be prevented from making certain common and arbitrary reservations in the interests of ease or self-interest.

Unjustified limitations are placed on the outworking of Christian love when, for example, we say that Christians ought not to concern themselves with politics—an assertion, one notices, often made by those who are doing well with things as they are, but who are not quite sure that their luck is going to hold out. This attitude is really tantamount to atheism which denies God's rule over public affairs. If we had more love, we would have more compassion towards our fellow-men, in particular towards the under-privileged whose lives, like our own, are strongly influenced for good or ill by impersonal legal, social and industrial systems, which systems therefore are the proper concern of the Christian.

Christian love is certainly, though not exclusively, concerned with individuals. It is concerned also with systems, with the social as well as the individual virtues. To

render witness in the political realm means two things: firstly, that the Christian as citizen or statesman defends the personal Christian virtues such as honesty, fair dealing, equity, incorruptibility; and secondly, that he seeks to evaluate the structures of society in the light of the Christian gospel, and to remove such structures as embody injustice, and to work for a transformation of society so that men and women may be enabled to fulfil their entire calling as responsible creatures of God, for whom Christ died.

Now no social order can work simply on the basis of absolute love; and prisons, police courts, and punishments signify the necessary place of justice in the social order. But some social orders, for example, those which care for the aged, the sick, the unemployed, and the under-privileged, show more of love than others in which concern is absent. The relationship between love and justice can be adequately described only in dialectical terms, that is, in terms which have the element of contradiction in them. Love both fulfils and negates justice. Cases in which justice contradicts love are obvious enough, but notice also that love may be the motive leading us to seek justice for others, and that love and punishment are by no means incompatible: "Whom the Lord loveth He chasteneth." Mere justice, mere mutuality, are manifestly insufficient as a basis of normal human relations, to say nothing of Christian relations. May it not be that this manifest insufficiency, even the teaching of the New Testament apart, reveals at least obscurely that a rational examination of human social relations indicates that love indeed is the law of life?

Christians commonly make two errors in seeking to apply love as a criterion and guide for political thought and action. Either we see love as simply applicable to public affairs, and this being impossible, we lapse into utopianism. We "bleat fatuously about love," in Archbishop Temple's phrase, and deservedly evoke from the oppressed and the underprivileged the protest: "To hell with charity, we want justice!"

Or we declare that love is politically irrelevant and lapse into pessimism and cynicism. If God's law is the law of love, then its writ runs through the whole of life. Authentic Christian teaching here is that love is a transcendent but relevant norm for social existence. No social order can ever completely fulfil love; nor can it fulfil justice either, for no

society is perfect. But different social orders fulfil love and justice in varying degrees, and the Christian is called to work so that the social order in which we live fulfils as much of love and justice as is possible; and zeal for social justice is one very urgent expression of Christian love.

Now love knows no limits, and if the love of Christ constrains us, we shall find it impossible to stop short where discretion and self-interest dictate a halt. There is a basic connection between Christian love and political action. Political action proceeds from the very centre of the Christian faith, and it is not an option or alternative. We are members one of another in more senses than one, and our every action, and not less our inaction, have unsuspected repercussions in the lives of our fellow-men. "Any man's death diminishes me, because I am involved in mankind." (John Donne.)

The mainspring of sound Christian political action is in Christian love, in its increase in sensitivity, imagination and compassion for the needs of our fellow-men. To justify Christian political action, we may evoke the categories of natural law, the Christian doctrine of man, biblical example, the precepts of traditional philosophy and theology. We can do that. These in fact may in certain circumstances be indispensable, but they are the long way around, because it's not more knowledge that we need. What the world needs today is reformation and redemption. Increase in knowledge may be as ineffective as attempts to cure indigestion by eating more food.

Thus, in the Pauline writings, it is not in the thirteenth chapter of Romans, where we read of "the powers that be" and of our obligation to them, that we find the dynamic of Christian political action, but in the thirteenth chapter of First Corinthians where the apostle in effect repeats the words and evokes the spirit of Christ, who said in the thirteenth chapter of St John's Gospel: "A new command-ment I give unto you, that you love one another, even as I have loved you, that you also love one another."

Look now at the nature of politics from the standpoint of Christian teaching, both biblical and philosophical. It is one of the unique contributions of Christian teaching to insist that there is a vital connection between our faith and politics. The political life of man is indeed of this world, but the way of salvation does not lie in escaping from the so-

called secular, unredeemed spheres of human activity. It occurs, on the contrary, in claiming them for God, and in working to conform them in the here and now to God's purpose as revealed in Christ.

At the heart of this, we see that the Christian world-view lays down very clearly the proper relationship between so-called material affairs or matter—history, politics, economics, race relations and other so-called material or secular concerns—on the one hand, and spirit on the other. Salvation, exemplified in theology, in worship, in prayer, in man's personal relationship to God, according to both early and 20th century Christian heresies, lies in dismissing material concerns as evil or illusory. But orthodox Christian teaching, as I understand it, confronts matter realistically, insisting that the way to be spiritually effective is not to ignore it but to claim it for transformation by the grace of God.

That is what Archbishop Temple meant when he said in a memorable phrase that "Christianity is the most avowedly materialist of all the great religions." It is materialist not in the sense that it denies the reality and efficacy of spirit, but because the Christian faith sees that matter and all that it connotes is part of God's created work, and that God's work of redemption is not less than his work of creation.

So in the Epistle to the Colossians: "By Him [Christ the Son] were all things created, in heaven and in earth, visible and invisible, whether thrones or dominions or principalities or powers; all things were created by Him and for Him. He is before all things, and by Him all things consist." Christ is the open secret of the universe.

The words "all things" outrule that dualism which has been a temptation to Christians in all ages, and not least in our own, to limit the sphere of God's redemptive activity to things spiritual. This, as we have noted earlier in a similar context, is a practical atheism which denies God's purpose and power in part of His creation, in the world of public affairs.

The social order, the political and the economic order, are part of God's created work, and they indeed give evidence that they are fallen. Corruption and sin disfigure God's original and perfect intention for them, but they still lie within the scheme of God's redemptive purpose and power. And God calls fallen man, made in His image and the

crown of His creation, to work with Him, and by His grace
to effect the redemption of the world. Herein lies the
Christian mandate for political concern. Herein is the
Christian antidote to cynicism, hopelessness, pessimism,
utopianism. Here is also the perennial source of Christian
radicalism and Christian optimism concerning the political
order. The Christian is equipped to be a constructive radical
in any social order.

I conclude with an attempt to bring into actuality some of
these issues. I've talked about our Christian witness as
involving our participation in these issues that confront our
society, our nation and our civilisation today. And almost
telegraphically, I would refer to three issues, which, on
coming back to this country after forty years' absence, strike
me as significant.

In a way I think I'm excluded from having my views
taken with very great seriousness because I've been absent
for so long. But on the other hand, there's a sense too that
in coming back after so long, it's the spectator who best sees
what's going on in the game. At any rate, I would risk
saying this to you tonight, if I may: There are three issues
that seem to me to be of the gravest importance, which
should be the proper concern and care of all Christian
people today who wish to participate in the work and the
witness of the Church in our generation.

The first of these is nuclear disarmament. Second is the
phenomenon of mass unemployment; and third, race
relations.

At the General Assembly in May 1986, which I had the
honour of chairing as Moderator, this resolution was passed:

"As of now this General Assembly declares that no
Church can accede to the use of nuclear weapons to
defend any cause whatever, and calls on Her Majesty's
Government to desist from their use and from their
further development."

Now you may agree or disagree with that; and we are
not an authoritarian Church, and surely the Church is one
place in which people can agree to differ and still remain in
fellowship and friendship. Where we will all agree, I think,
is that this is a matter that deserves the most careful and
concerned attention of every Christian man and woman.

The second issue to which I've referred is unemployment, on which the General Assembly has made these deliverances:

"Recognising that the present levels of unemployment are a denial of our sense of community as a nation, call upon Her Majesty's Government to adopt economic and industrial policies which give priority to the solution of the problem." (1985)

"Call upon Her Majesty's Government and all political parties to give priority to shaping policies to deal with long-term structural changes needed to provide a fairer framework for employment in this country." (1986)

I am old enough to remember the worst days of the depression in the 1930s. I don't know what the situation is here in these islands concerning unemployment, but during my Moderatorial visitations to Presbyteries I was in a very good secondary school near Alexandria in the Vale of Leven. I spoke to the headmaster and said to him, "How many of your young people leaving school—that is, leaving school at the age of 16 to 18—are likely to gain employment?" and the answer to me was 20 per cent; 80 per cent of the young people unemployed.

Now what the remedy of this is, I cannot pretend to know, but here again is a question which surely can unite Christians of different political persuasions. Here is a blot on the face of a country that professes and calls itself Christian, the denial to our young people through other priorities which, whatever they are, need to be reversed to meet the claim, indeed the natural right, of every man and woman to work. A great deal of the ills from which our country is suffering, morally and medically, as has been statistically proven, find their causes in unemployment. To allow this to continue means that as a nation we are sowing the wind of which we shall reap the whirlwind.

The third issue which today is an inescapable concern of all Christian people is race relations. I have just returned from three weeks in South Africa and Zimbabwe, where previously I worked for 25 years in multi-racial university education. Here is a question of which I, unlike some other

questions, can claim some knowledge, and perhaps even a modicum of authority. On race relations and in particular reference to South Africa, the General Assembly at its meeting in May 1986 made these deliverances:

> "Urge the South African Government to move towards giving their rightful place in the government of their country to the black majority."

> "Instruct the Church of Scotland Trust to review once again its investment policy with a view to ensuring that the Church does not derive profit from investment in companies which have a substantial stake in the South African economy. Call upon Her Majesty's Government to impose the targeted sanctions on South Africa approved by the EEC and the countries of the Commonwealth; and to provide increased aid for those countries of Southern Africa whose economies may suffer."

These three are only examples of issues which I believe should engage our attention as we reflect on the subject on which I was asked to speak this evening. These and other issues are certainly part and parcel of the witness and work of the Church as it faces its task in today's world.

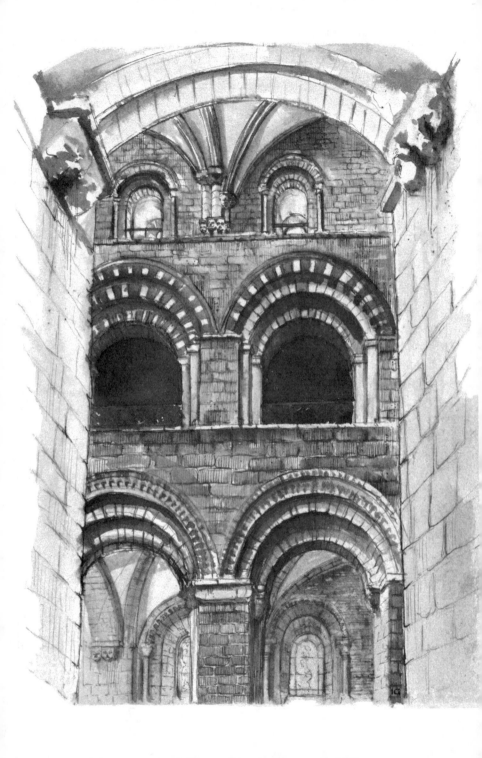

APPENDIX
Ian B. Cowan

Native sources for establishing the history of the
Cathedral and its clergy during the Middle Ages are
extremely limited. It is thus fortunate that research in the
Vatican archives has added a new dimension to the
historian's knowledge of ecclesiastical organisation in the
Northern Isles before the Reformation. These records
collected under the auspices of the Ross Fund of the
University of Glasgow may be consulted there by prior
arrangement with the Department of Scottish History. If
most of these entries are routine, relating to benefices and
the priests who sought possession of their revenues, a few are
of wider interest. One in particular, which seeks an
indulgence for pilgrims visiting the Cathedral on certain feast
days, provides a pen-picture of the medieval Cathedral and
those who worshipped there.

10 May 1441	*Indulgentia*	Register of Supplications,
		373, 141

Since the church of Orkney of St Magnus the Martyr of
the kingdom of Norway is famed as one of the
principal cathedral churches of the said kingdom, is of
royal foundation and is dedicated to St Magnus the
Martyr (containing his bones, those of other saints and
many other relics), and since it is visited every year by
multitudes of pilgrims from divers parts of the said
kingdom who find it difficult to reach other places
outside their fatherland, Thomas bishop of Orkney,
who has been in the priestly dignity for over twenty
years and who is present in Curia, therefore supplicates
the Pope to grant in perpetuity seven years' indulgence
and as many quarantines of enjoined penitence to all
Christ's faithful who devoutly visit the said church
annually on the feasts and octaves of St John the Baptist
and the passion and translation of St Magnus the
Martyr and who give alms for its repair and

conservation, stretching out helping hands for the purpose, and also to grant that the said bishop or his penitentiary may absolve all such visitors from all fault, of commission and omission, from excommunication, even in cases specially reserved to the Apostolic See, and from inhability. *Concessum pro septem annis pro una festa* [Granted for seven years for one festival]. Florence.

If chaplains normally conducted services within the Cathedral, authority lay with the clergy collectively known as the chapter and individually as canons, to each of whom was assigned an individual prebendal allowance. These revenues were normally derived from the teinds of parish churches which in turn gave their names to the prebends which they supported. In Orkney, the first information is recorded in a roll dated 1327-1328 which relates to the payments of first fruits or annates, of the vacant benefices within the kingdom of Norway for these two years. As such, it includes a list of benefices within the diocese of Orkney and thus provides, not only the earliest appearance on record of the churches concerned, but also the first information as to the existence of a cathedral chapter in the diocese.

1327-28 Collectorie 295, 250
[TAX ROLL FOR THE DIOCESE OF ORKNEY]
Hec beneficia vacaverunt in civitate et diocese orchadensi infra predictum biennium qua solverunt fructus primi anni ut sequitur primo.
These benefices were vacant in the city and diocese of Orkney within the aforesaid two years [1327-1328] and paid the fruits of the first year as follows first.

prebenda de sconsay [Stronsay]	vi marcas argenti pondere Norwegiae (*6 merks of silver of Norwegian weight*)
vicaria de scronsay [Stronsay]	v marcas argenti eiusdem ponderis (*5 merks of silver of the same weight*)
ecclesia de vastray [Westray]	xv s. sterlingorum (*15 shillings sterling*)
ecclesia de hay [Hoy]	i marca argenti pondera predicta (*1 merk of silver of the foresaid weight*)

122

Prebenda de sandwik [Sandwick]	iii libras cum vii s. sterlingorum (*£3: 7 shillings sterling*)
ecclesia de dyrsnes [Deerness]	xxvi s. cum viii d. sterlingorum (*26 shillings 8 pence sterling*)
prebenda ecclesie sancte crucis de Be [Sanday]	iii libras cum xii s. sterlingorum (*£3: 12 shillings sterling*)
ecclesia de orfer [Orphir]	xx s. sterlingorum (*20 shillings sterling*)
prebenda domini Rikardi	xxxvi s. sterlingorum (*36 shillings sterling*)

As noted in the text, prebends before the 1544 reconstruction of the chapter may have been transient creations held on a personal basis rather than in terms of any established constitution, although six canons may have been the traditional number at any given point in time. Examples of such prebends derived from Vatican records include:

27 November 1429 Reg. Supp., 249, 31
Since the canonry and prebend of church of St Nicholas de Stronsay in church of Orkney are void because Angus de Birknes, who bears himself as priest, archdeacon of Zetland, a dignity to which a certain canonry and prebend are canonically annexed, obtained peaceable possession of above canonry and prebend [of Stronsay] by ordinary authority, and has held them for more than ten years along with archdeaconry and annexes against Constitution *Execrabilis* and without apostolic dispensation, therefore Alexander de Mernis, perpetual vicar of parish church of Rolsay, Orkney diocese, supplicates that Pope would provide him to foresaid canonry and prebend (£4 sterling), void as above or howsoever: notwithstanding the above vicarage of Rolsay, to which church of Elglesey, said diocese, is canonically annexed (£8 sterling). *Fiat ut petitur* [Granted as sought]. Rome.

26 October 1440 *Confirmatio* Reg. Supp., 368, 115v
Lately, when the can. and preb. of Orfare in the church

of Orkney became vacant through the death of
Laurence de Torrse and the vicarage of Ronaldsay and
Borrowray through the death of William de Welleini
[?], last possessors, Thomas bishop of Orkney, with the
advice and consent of the chapter, received Andrew de
Tulach, archdeacon of Orkney, his nephew, into a
canonry of the said church at the supplication of the
said archdeacon on account of the tenuity of the fruits
of the archdeaconry and provided him to the foresaid
prebend of Orfare, to be fully answerable for the rents
and profits of the vicarages of Ronaldsay and
Borrowray also, and annexed by ordinary authority the
said can., preb. and vicarage in perpetuity to the said
archdeaconry, on the condition that the archdeacon and
his successors visit the said church *de jure* to reform and
correct the persons serving God therein; and he did
otherwise as is contained in a public instrument by the
hand of Robert Michaelis de Hyrdmanstoun, clerk,
d. St A., notary public. In order that the annexations
and unions may have greater validity, the said
Archdeacon Andrew, of noble race, supplicates the
Pope to confirm the union, annexation and incorpo-
ration of the can., preb. and vicarage foresaid (£14) to
the said archdeaconry (£14) and, if need be, to
incorporate them anew: nws the perp. vic. of Coulle, d.
Aberd. (£5). *Concessum ut petitur de confirmacione*
[Confirmation granted as sought]. Florence.

11 March 1441 *Dispensatio* Reg. Supp., 372, 61v
Lately, the Pope dispensed Ector de Tulacht, priest,
d. St A., to be promoted to sacred orders and to hold a
benefice even with cure, nws defect of birth as son of
an unmarried nobleman and an unmarried woman, by
virtue of which he obtained the can. and preb. of
Scromseray in the church of Orkney together with the
chaplaincy of St Catherine in the same and holds them
at present. He therefore supplicates the Pope to abolish
all stain of inhability and infamy which he may have
incurred by reason of the foregoing and to dispense him
to hold for life any incompatible benefices with clause
of exchange and also to dispense him such that in future
impetrations he need not make mention of the said
defect of birth: nws the said defect and the can. and

preb. of Scromseray in the church of Orkney and the chaplaincy of St Katherine (total fruits £5). *Concessum de omnibus* [Granted for all]. Florence.

11 March 1441 *Dispensatio* Reg. Supp., 372, 62

Lately, the Pope dispensed Thomas de Tulach, clerk, d. St A., as above, by virtue of which he obtained the can. and preb. of Westra in the church of Orkney, together with a chaplaincy (of lay patronage) in the church of Brechin and he holds them together at present. He therefore supplicates the Pope to absolve him and to dispense him to hold incompatibles and that he need not mention his defect of birth: nws the defect of birth, the can. and preb. of Westray (£5) and the chaplaincy in the church of Brechin (£4). *Concessum de omnibus.* Florence.

While most of the information available is understandably of an ecclesiastical nature, records of land held by the Church are of wider significance, as the following example illustrates.

12 September 1484 Reg. Lat. 847, folios 381v - 384r

To the archdeacon and dean of the church of Orkney, mandate, Subsequent to the issue of the letter of Paul II, *Ad perpetuam rei memoriam. Cum in omnibus judiciis . . .,* dated at St Peter's Rome, 11 May 1465, which the Pope here exemplifies in full, Sixtus IV was informed by Andrew, then as now bishop of Orkney, that, considering it of benefit to his episcopal *mensa* [table] and with the express consent of the chapter of Orkney, the said bishop had granted to Giles Farquhar, a layman of the said diocese, and his wife Elizabeth, for their life or for a maximum of nineteen years, a lease of one holding of land, known as Stansakir, in the parish of Eby, and of the whole island of Flactay, namely nine 'denariates' of land,—all lawfully belonging to the episcopal *mensa* of Orkney—in return for an annual cess of 10 pounds Scots, payable each year to him and his successors, bishops of Orkney, at a certain time and place then specified, as was said to be more fully contained in a certain authentic letter of the bishop,

drawn up in this regard and sealed with his seal. At the supplication of the said Andrew, Giles and Elizabeth, Sixtus, who had no certain knowledge of this matter and who wished to have exact details of the situation, quality, quantity, value and boundaries etc. of the said lands and island, on 23 June, twelfth year [1483], granted the issue of a mandate to certain judges, ordering them to obtain details of the said lands and to confirm the lease and grant—supplying any defects— subject to its being in conformity with the letter of Paul II and of benefit to the *mensa* and provided that the chapter consented to it. Since Sixtus, however, died before his letter of mandate was drawn up, the Pope hereby decrees that the grant made by Sixtus shall have effect from the said date as if his letter had then been drawn up and that the present letter shall be sufficient proof thereof, and orders the above two to execute its provisions.

Other materials from the diocese of Orkney are gradually being calendared, including the records of the court of the Penitentiary, which with the notices of legitimations and marriage dispensations will supply valuable genealogical information for both Orkney and Shetland. If the material is sparse in relation to other parts of Scotland, these records, nevertheless, provide a welcome addition to scholarly infor- mation about these islands.

Notes on the Chapters

Origin and Context

1. The quotation from J. Storer Clouston comes from the radio talk *Voices of St Magnus* by Ernest W. Marwick (Radio Orkney Sound Archive, TA/5, 1977).
2. Richard Barber, *The Penguin Guide to Medieval Europe* (Harmondsworth, 1984), 135.
3. *ibid.*, 36-7.
4. *ibid.*, 58.
5. Hugh Braun, *A Short History of English Architecture* (London: Faber & Faber, 1950), 26.
6. *ibid.*, 27-8.
7. For a concise and clear insight into the economic and political background to this period, see Richard Hodges and David Whitehouse, *Mohammed, Charlemagne and the Origins of Europe* (London: Duckworth, 1983).
8. Henri Pirenne, quoted in Hodges & Whitehouse, *Mohammed, Charlemagne*, 4, 82. Pirenne developed the link between the Islamic conquests and the rise of Charlemagne in *Mohammed and Charlemagne* (London, 1939).
9. The significance to the West of the supply of silver from the Islamic world was brought out by Sture Bolin in 'Mohammed, Charlemagne and Ruric', *Scandinavian Economic History Review* 1, 1952.
10. This picture of the Vikings on the edge on society, distinct from the Norse commerce they preyed on, was advanced by Alfred P. Smyth in *Scandinavian Kings in the British Isles 850-880* (Oxford, 1977) and *Warlords and Holy Men: Scotland AD 80-1000* (London: Edward Arnold, 1984).
11. Barber, *Medieval Europe*, 197.
12. Trevor Rowley, *The Norman Heritage* (London: Paladin, 1984), 24-5.
13. For Orkney links with Scotland at this time, and Scottish links with Durham, see Gordon Donaldson, 'The Contemporary Scene', in Barbara Crawford, *St Magnus Cathedral and Orkney's Twelfth-Century Renaissance* (Aberdeen, 1988).
14. The architectural similarities—and differences also— between the cathedrals are described in detail in chapters by Stewart Cruden, Richard Fawcett and Eric Cambridge in Crawford, *St Magnus Cathedral*.
15. For a detailed analysis of the origins and cultural links of the *Hymn to St Magnus*, see Ingrid De Geer, 'Music and the Twelfth Century Earldom: A Cultural Crossroads in Musicological Perspective', in Crawford, *St Magnus Cathedral*.
16. Stewart Cruden, 'The Founding and Building of the Twelfth-Century Cathedral of St Magnus', in Crawford, *St Magnus Cathedral*, 79.

17. For a study of Norwegian influences in the second phase of building, see Ronald Cant, 'Norwegian Influences in the Design of the Transitional and Gothic Cathedral,' in Crawford, *St Magnus Cathedral*.
18. See, for example, Peter Foote, 'Observations on *Orkneyinga saga*,' in Crawford, *St Magnus Cathedral*.

The Medieval Bishops

1. *Fasti Ecclesiae Scoticanae Medii Aevi ad annum 1638*, ed. D.E.R. Watt (Scottish Record Society, 1969), 247.
2. *ibid.*, 247.
3. *ibid.*, 247; *Orkney Heritage: vol. 2—Birsay: A Centre of Political and Ecclesiastical Power*, ed. W.P.L. Thomson (Kirkwall, 1983).
4. Watt, *Fasti*, 247-8.
5. *ibid.*, 248; *The Bishops of Scotland*, ed. J. Dowden (Glasgow, 1912), 253-4.
6. Watt, *Fasti*, 248.
7. *ibid.*, 248; Dowden, *Bishops*, 254.
8. Watt, *Fasti*, 248-9; Dowden, *Bishops*, 254-5.
9. Watt, *Fasti*, 248-9; Dowden, *Bishops*, 254-5.
10. Watt, *Fasti*, 248; Dowden, *Bishops*, 252-3.
11. *Orkneyinga Saga*, ed. A. B. Taylor (Edinburgh, 1938), 321, 328, 338; *Reports of the Royal Commission on Ancient and Historical Monuments and Construction, Orkney and Shetland*, 3 vols (Edinburgh, 1946) ii, 114-141.
12. Watt, *Fasti*, 249, 254; Dowden, *Bishops*, 252-3.
13. Watt, *Fasti*, 250; Dowden, *Bishops*, 256-7.
14. *Calendar of Entries in the Papal Registers relating to Great Britain and Ireland: Papal Letters [CPL]*, edd. W. H. Bliss and others (London and Dublin, 1893), i, 241; Watt, *Fasti*, 250; Dowden, *Bishops*, 257-8.
15. *Jean XXII (1316-34) : Lettres Communes Analysees D'apres les Registres dit D'Avignon et du Vatican*, ed. G. Mollat, 16 vols (Paris, 1904-47); G. Barraclough, *Papal Provisions* (Oxford, 1935).
16. *CPL*, iv, 336; Watt, *Fasti*, 251.
17. *Calendar of Papal Letters of Clement VII of Avignon 1378-1394*, ed. C. Burns (Scottish History Society, 1976), xxxiv-xxxix.
18. Watt, *Fasti*, 251; Dowden, *Bishops*, 259-60.
19. Watt, *Fasti*, 251; Dowden, *Bishops*, 260.
20. Watt, *Fasti*, 251.
21. *ibid.*, 251.
22. *ibid.*, 251-2.
23. *Calendar of Papal Letters of Benedict XIII of Avignon 1394-1419*, ed. F. McGurk (Scottish History Society, 1976), x-xi.
24. Watt, *Fasti*, 252.
25. *ibid.*, 60, 252.
26. *ibid.*, 252.
27. *ibid.*, 252-3; Dowden, *Bishops*, 261.
28. Watt, *Fasti*, 253; Dowden, *Bishops*, 261-2.

29. Barbara Crawford, 'The pawning of Orkney and Shetland' in *Scottish Historical Review*, xlviii (1969), 35-53; *Vetera Monumenta Hibernorum et Scotorum Historiam Illustrantia*, ed. A. Theiner (Rome, 1864), no. lcccxlii.

30. Watt, *Fasti*, 253; Dowden, *Bishops*, 262-3.

31. J. Herkless and R. K. Hannay, *Archbishops of St Andrews* (Edinburgh, 1907-15), i, 157-8.

32. Watt, *Fasti*, 253-4; Dowden, *Bishops*, 264-5.

33. Watt, *Fasti*, 254.

34. *CPL*, i, 241.

35. Watt, *Fasti*, 259, 261.

36. *ibid.*, 254-5.

37. *ibid.*, 255.

38. Simon Ollivant, *The Court of the Official in Pre-Reformation Scotland* (Stair Society, 1982), *passim;* Watt, *Fasti*, 264-5.

39. *The Acts of the Parliaments of Scotland*, edd. T. Thomson and C. Innes (Edinburgh 1814-75), i, 420.

40. Ian B. Cowan, 'Two Early Scottish Taxation Rolls', in *Innes Review*, xxii (1971), 6-11.

41. Ian B. Cowan, *The Parishes of Medieval Scotland* (Scottish Record Society, 1967), 18, 24, 80-1, 83, 125, 160, 179-180, 185-6, 192-3, 197, 207-9.

42. A. Peterkin, *Rentals of the Ancient Earldom and Bishoprick of Orkney* (Edinburgh, 1820), Appendix v, 18-25.

43. *Proceedings of the Society of Antiquaries of Scotland* (1851), 3rd series, xvi, 195; *Registrum Magni Sigilli Regum Scottorum*, edd. J. M. Thomson and others (Edinburgh 1882-1914), iii, no. 3102.

44. *ibid.*, iii, no. 3102; Cowan, *Parishes*, 18, 80-1, 197, 207, 209.

The Eighteenth-Century Church

Abbreviations

OSA *(Old Statistical Account)* = D. J. Withrington and I. R. Grant, *The Statistical Account of Scotland, Vol. XIX, Orkney & Shetland*, 1978. For many Orkney readers the edition by J. Storer Clouston, *The Orkney Parishes*, 1927, may be more accessible.

Pres. Recs. = The Records of the Presbytery of Orkney, after 1707 the Presbytery of Kirkwall (manuscript volumes).

Ses. Recs. = Kirkwall, St Magnus Cathedral, Session Records (manuscript volumes).

1. The Orkney ministers who were deposed in 1662 were Alexander Lennox of the Kirkwall first charge and Arthur Moray of Lady Parish, Sanday. See John Smith, *Annals of the Church of Scotland in Orkney from 1560*, 1907, pp.56, 268-269, and J. B. Craven, *History of the Church in Orkney, 1662-1688*, p.10.

2. The first meeting of Presbytery was on 28 June 1697, the ministers present being James Graham (Holm), John Cobb (Stronsay & Eday) and Thomas Baikie (Kirkwall).

3. The minutes of the Commissions of 1698 and 1700 are copied verbatim into *Pres.Recs.*

4. A detailed account of the Episcopalian meeting house can be found in J. B. Craven, *The Episcopalian Church in Orkney, 1688-1882,* 1883.

5. Commission of 1698; Commission of 1700; Alexander Goodfellow, *Sanday Church History,* 1912, pp.58-61.

6. Commission of 1698.

7. James Lyon, *A Short Account of the Divine Original of Episcopacy,* 1710, preface.

8. Commission of 1698.

9. John Tudor, *The Orkneys and Shetlands,* 1883, p.84, quoting a 1760 pamphlet, *A Familiar Epistle from his Excellency the Lord Lieutenant of Orkney to his Mightiness the Prolocutor of the Athelnstonford Congregation in East Lothian.*

10. James Lyon, *op.cit.,* preface.

11. *Pres.Recs.,* 4 September, 1719.

12. *Pres.Recs.,* 4 September, 1719.

13. John Smith, *op.cit.,* p.77.

14. James Sands, *A Letter directed thus, For Mr James Lyon in Kirkwall,* 1710.

15. *Pres.Recs.,* 28 and 29 September, 1709.

16. John Tudor, *op.cit.,* pp.584-590.

17. *Pres.Recs.,* 2 September 1719.

18. Thomas Baikie's Grievances, Commission of 1698.

19. James Lyon, *op.cit.,* preface.

20. John Cobb's Grievances, Commission of 1698.

21. Mss letter, Rev. James Graham to Presbytery, 30 April (no year stated).

22. Mss letter, Rev. John Keith to Presbytery, 25 May 1709.

23. Gordon Donaldson, 'Covenant to Revolution', in Duncan Forrester, *Studies in the History of Worship,* 1984.

24. Henry Sefton, 'Revolution to Disruption' in Duncan Forrester, *op.cit.*

25. John Brand, *A Brief Description of Orkney, Zetland, the Pightland Firth and Caithness* (1700), 1883, p.61.

26. See the criticisms of the eighteenth-century church in Orkney made in David Webster, *The History of the Kirkwall United Presbyterian Congregation,* 1910, pp.1-2, and John Paterson, *Memoir of Robert Paterson, D.D.,* 1874, pp.17-18.

27. *Pres.Recs.,* 28 September, 1709.

28. Commission of 1698.

29. J. B. Craven, 1883, *op.cit.,* p.112.

30. James Lyon, *op.cit.,* p.141.

31. The 'Mutton Covenant' is printed in John Tudor, *op.cit.,* pp.591-593.

32. John Willcock, *A Shetland Minister of the Eighteenth Century,* 1897, p.52n.

33. Kirkwall, St Magnus Cathedral, Sermons by Robert Baikie (*recté* Thomas), manuscript volume.

34. Commission of 1698.

35. The difficulties in persuading heritors to fulfill their legal duties in relation to the upkeep of churches are graphically described in V.C. Pogue's 'Church Life in Orphir Two Hundred Years Ago', *Orkney Miscellany,* Vol.2, 1954.

36. *OSA,* St Andrews and Deerness, p.209.

37. *OSA*, St Andrews and Deerness, p.209.
38. *OSA*, Hoy and Graemsay, p.109.
39. *OSA*, Walls and Flotta, p.348.
40. *OSA*, Hoy and Graemsay, pp.111-112.
41. *OSA*, Rousay, Egilsay and Wyre, p.198.
42. *OSA*, Stronsay and Eday, p.332.
43. *OSA*, Evie and Rendall, pp.82-83.
44. For example, *Ses.Recs.*, 6 October 1718, 19 October 1719, 16 November 1730 and 1740 *passim*.
45. *Ses.Recs.*, 1740.
46. Alexander Peterkin, *Notes on Orkney and Zetland*, 1822, p.29.
47. Alexander Peterkin, *Notes*, p.29.
48. *Pres.Recs.*, 8 August 1701 (also printed in Alexander Peterkin, *Rentals of the Ancient Earldom and Bishoprick of Orkney*, 1820, Appendix p.71).
49. John Mooney, *Charters and Other Records of the City and Royal Burgh of Kirkwall*, 1952, pp.19, 25.
50. Alexander Peterkin, *Rentals*, Appendix pp.74-75.
51. Alexander Peterkin, *Rentals*, Appendix p.76.
52. Alexander Peterkin, *Rentals*, Appendix, pp.77-81; *OSA*, Kirkwall and St Ola, pp.138-139.
53. V. C. Pogue, 'The Case of the Rev. James Tyrie', *Orkney Miscellany*, Vol.4, 1957.
54. R. P. Fereday, *Orkney Feuds and the '45*, 1980, p.152 note 29.
55. Francis Liddell, *The Melancholy Case of Mr Francis Liddell*, 1808.
56. Sample based on information contained in biographies by John Smith, *op.cit.*
57. In 1698 there was a "Grammar School" in Birsay run by David Thomson. It was still in existence in 1709, by then run by Alexander Guthrie, when it was described as "ane English and Latine school" (*Pres.Recs.*, 27 June 1698 and 28 September 1709). In 1719 a school of "humanity and philosophy" had a brief existence in Stromness (*Pres.Recs.*, 3 February 1720).
58. In 1747 the Rev. Edward Irvine gave evidence that the stipend of the Kirkwall first charge consisted of:

72 meils of malt (=c. 5,090 kg.) 1 barrel of butter £224 Scots (=£18⅔ stg.)	These items were payable out of the bishopric. The Chamberlain was responsible for payment, which was found from the Prebend of St Peter in St Ola parish.
7 meils of malt (c. 507 kg.)	This represented parsonage teinds, and was paid out of the Prebend of St John in Campston, St Andrews parish.
10 marks Scots and 1 meil of malt.	This was feu duty for Pipersquoy, land feued from the glebe.

(Source: *Pres.Recs.*, 13 May 1747, printed in Alexander Peterkin, *Rentals*, Appendix, p.78. Further information on the stipend is printed

in Sir Arthur Mitchell, *Geographical Collections relating to Scotland made by Walter Macfarlane,* 1906, Vol.1, pp.145-146).

59. *OSA,* South Ronaldsay, p.190.
60. *OSA,* Kirkwall and St Ola, p.138.
61. *OSA,* Holm, p.105.
62. *OSA,* Westray, p.361.
63. *OSA,* Firth and Stenness, p.98.
64. *OSA,* Birsay and Harray, p.11.
65. *OSA,* Kirkwall and St Ola, p.138.
66. *OSA,* Stronsay and Eday, p.332.
67. *OSA,* Evie and Rendall, p.83.
68. *OSA,* Cross and Burness, pp.61-62.
69. *OSA,* Orphir, p.162.
70. 1698 Commission, 'Grievances of the Presbytery'.
71. *Pres.Recs.,* 13 May 1747, printed in Alexander Peterkin, *Rentals,* Appendix p.78.
72. 1698 Commission.
73. B. H. Hossack, *Kirkwall in the Orkneys,* 1900, p.245; Sir Arthur Mitchell, *Geographical Collections,* Vol.1, p.151.
74. Action for division of run-rig, Sheriff Court, Kirkwall, SC11/5/51.
75. Map of Island of Shapinsay, 1846, Orkney Archives.
76. *OSA,* Holm, p.103.
77. *OSA,* Kirkwall and St Ola, p.53.
78. The elders who were ship-owners were John Coventrie (see: B. H. Hossack, *op.cit.,* pp.52, 94, 100, 127, 133, 135; Hugh Marwick, *Merchant Lairds of Long Ago,* 1939, Vol.2, p.60), William Traill (see: B. H. Hossack, *op.cit.,* pp.90, 130, 132, 136, 152), Magnus Johnson (see: Hugh Marwick, *Merchant Lairds,* Vol.1, pp.48, 50), and David Strang (see: B. H. Hossack, 97, 155, 211, 299, 345, 438, 443).
79. B. H. Hossack, *op.cit.,* p.195.
80. A Francis Steuart (ed.), *The Diary of Thomas Brown,* 1898, pp.36, 37.
81. B. H. Hossack, *op.cit.,* p.153.
82. *Ses.Recs.,* 10 September 1722 *et seq;* B. H. Hossack, *op.cit.,* p.314.
83. *Ses.Recs.,* 13 May 1730.
84. *Ses.Recs.,* 18 October 1719.
85. *Ses.Recs.,* 12 March 1722 until 3 September 1722.
86. *Ses.Recs.,* 28 May 1739 *et seq.*
87. *Ses.Recs.,* 23 October 1721 until 12 February 1722.
88. For example, when Marjorie Wallace was alleged to have slandered Bess Laughton by accusing her of stealing a small quantity of washing, the case occupied no less than eleven meetings of the Session between 10 December 1711 and 10 March 1722, by which time it was so complicated that it was referred to the Presbytery.
89. Eighteenth-century ministers treated witchcraft as a delusion, rather than as a serious threat. Even when the 1698 Commission was anxious to discredit the Rev. James Heart in Shapinsay, it simply ignored complaints from Shapinsay people that their minister "winks and connives at sin", and ignores "much wickedness, witchcraft and sorcery".
90. John Tudor, *op.cit.,* p.383, tells the story of the Westray man who interrupted preparations for his wife's funeral to join in a whale hunt. When the laird expressed surprise at seeing him, the man replied,

"Well, you see, laird, I couldn't afford to lose both wife and whales the same day."

91. *Pres.Recs.*, 17 June 1708.
92. B. H. Hossack, *op.cit.*, p.364.
93. John Brand, *op.cit.*, pp.87-90, 94. Other descriptions of these vestigial traces of Catholicism are to be found in Ernest W. Marwick, *The Folklore of Orkney and Shetland*, 1975, p.135, and John Tudor, *op.cit.*, p.278.
94. David Webster, *The History of the Kirkwall United Presbyterian Congregation*, 1910, p.1.
95. *OSA*, Walls and Flotta, p.351.
96. *OSA*, Firth and Stenness, p.90; John Pemberton, *The Life and Travels of John Pemberton, a Minister of the Gospel of Christ*, 1844; D. P. Thompson, *Orkney Through the Centuries*, 1956, pp.13-16.
97. J. Haldane, *Journal of a Tour through the Northern Counties of Scotland and the Orkney Islands*, 1798.
98. *OSA*, Stronsay and Eday, p.340n.

Nineteenth-Century Aspects

1. Rev. J. Paterson, *Memoir of Robert Paterson D.D.* (Elliot: Edinburgh, 1874), 95-6.
2. *ibid.*, 96.
3. *ibid.*, 96.
4. *Sixty Years a Holy Place* (Herald Office: Kirkwall, 1953), 1.
5. Paterson, *Memoir*, 97.
6. *ibid.*, 99.
7. *ibid.*, 99.
8. *ibid.*, 101.
9. W. Logie, D.D., *Memorial Notice to the Sermons and Services of the Church*, 12.
10. *ibid.*, 18.
11. *ibid.*, 21.
12. *ibid.*, 23.
13. *ibid.*, 25-6.
14. *ibid.*, 29.
15. *ibid.*, 33-4.
16. B. H. Hossack, *Kirkwall in the Orkneys* (Peace: Kirkwall, 1900), 453.
17. *ibid.*, 454.
18. Rev. P. Petrie, *Narrative respecting the New Place of worship lately erected in Kirkwall* (Johnstone: Edinburgh, 1842), 7.
19. *ibid.*, 7.
20. Rev. W. Logie, *Letter to Congregation of the Established Church, Kirkwall*, 1-2.
21. *ibid.*, 3.
22. Petrie, *Narrative*, 9.
23. Logie, *Letter to Congregation*, 3.
24. Logie, *Memorial Notice*, 34-5.
25. *ibid.*, 36.
26. *ibid.*, 36.

Notes on Contributors

Colonel R.A.A.S. Macrae, MBE, has been Lord Lieutenant of Orkney since 1972. He was commissioned in the Seaforth Highlanders in 1935, and served in the BEF with the 51st Highland Division in 1940 before being captured at St Valery and becoming a prisoner of war. After the war he served on the British Military Mission to Greece in 1951, and was in Korea with the 1st Battalion the Black Watch in 1952 and in East Africa in 1953. Since retiring from the Army in 1967 he has been farming in Orkney, and was for eight years a member of Orkney Islands Council and Vice-Chairman of Orkney Health Board. He is an Honorary Sheriff for the Grampian, Highlands and Islands area, and Chairman of the Save St Magnus Appeal and the Society for the Friends of St Magnus Cathedral.

H.N. Firth, who co-edited the papers, is a writer, broadcaster and science and communications consultant. He is a former pupil of Stromness Academy, and holds a First Class honours degree in Mathematical Physics from Edinburgh University. Following a period of teaching in island schools, he joined the BBC to set up Radio Orkney. After further work with BBC Scotland in news and current affairs and education, he became the first Director of the Edinburgh International Festival of Science and Technology. He is the author of *Tales of Long Ago* (1986) and co-editor of *The People of Orkney* (1986), and has contributed to various other books, including *The Radical Approach* (1975).

Councillor Edwin R. Eunson, OBE, has been Convener of Orkney Islands Council since 1978. Born in Kirkwall and educated at Kirkwall Grammar School, he spent his working life in business in the town, but from an early age was involved in public life. He was a member of the former Kirkwall Town Council from 1947 to 1968, and has been a member of Orkney Islands Council since its inception in 1974. He has represented the Islands Council in numerous national and international forums, including the Conference of the Peripheral Maritime Regions of the EEC, and he holds the award of Commander of the Royal Norwegian Order of Merit. He was Chairman of Orkney Liberal Association for 16 years, and closely involved in all the election campaigns of Mr Jo Grimond as MP for Orkney and Shetland. Mr Eunson was Session Clerk of Kirkwall East Church from 1955 to 1987, and is a former Chairman of Kirkwall Chamber of Commerce.

Professor Ian Cowan holds the chair of Scottish History at the University of Glasgow. A graduate of the University of Edinburgh at which he commenced his teaching career, he subsequently lectured at Newbattle Abbey College before moving to Glasgow in 1962. He was president of the Scottish Church History Society from 1971 to 1974, and

editor of the *Scottish Historical Review* from 1983 to 1988. His books *The Parishes of Medieval Scotland* and *Medieval Religious Houses—Scotland* (with D.E. Easson) incorporate some of his research on the entries relating to Scotland in the Vatican Archives. He is also author of *The Enigma of Mary Stuart, The Scottish Reformation—Church and Society in Sixteenth-Century Scotland* and *The Scottish Covenanters, 1660-1688.*

The Very Rev. Dr Duncan Shaw, minister of Craigentinny in Edinburgh since 1959, was Moderator of the 1987 General Assembly. After war service in India and the Far East, he studied for the ministry at Edinburgh University, and his first charge was the former Edinburgh parish of St Margaret. He has a PhD from Edinburgh, and an honorary doctorate from the Comenius Faculty of Theology in Prague. His contribution to European understanding has been recognised by a number of awards, including the German Bundesverdienstkreuz Erster Klasse and the Patriarchal Cross of the Romanian Orthodox Church. He founded the Scottish Society for Reformation History in 1980, and has produced a number of books on the history of the Reformation. Dr Shaw has been secretary of the General Council of the University of Edinburgh since 1965.

William P.L. Thomson has been Rector of Kirkwall Grammar School since 1971. Previous to this he was in Shetland as Principal Teacher of History and Geography in the Anderson High School, Lerwick. His book *History of Orkney* (1987) was the first new history of the islands to appear for over half a century. He is also the author of *The Little General and the Rousay Crofters* (1981), *Kelp-making in Orkney* (1983), and of numerous articles on the economic and social history of Orkney and Shetland.

The Rev. H.W.M. Cant has been Minister of St Magnus Cathedral since 1968. Prior to this he was Minister of Fallin Parish Church from 1951 to 1956, Scottish Secretary of the Student Christian Movement from 1956 to 1959, and Minister of St Thomas Church in Leith from 1960 to 1968. He originally graduated MA at Edinburgh University and then after wartime service with the KOSB and KAR returned for a BD degree. He followed this with an STM at the Union Theological Seminary, New York. His written work includes the books *Preaching in a Scottish Parish Church (1970)* and *Springs of Renewal in Congregational Life (1980).*

The Rev. Ronald Ferguson was leader of the Iona Community from 1981 to 1988. He is a graduate, MA, from St Andrews University, and was for a number of years a journalist before taking a BD at Edinburgh University and entering the ministry. His first parish was Easterhouse in Glasgow, where he served from 1971 to 1979. He is author of the books *Geoff: The Life of Geoffrey M. Shaw* (1979), *Grace and Dysentery: Personal Reflections on a Visit to India* (1987) and *Chasing the Wild Goose* (1988), and joint editor of *The Whole Earth Shall Cry—GLORY: Iona Prayers by Rev. G. F. MacLeod.* He is currently engaged in writing the biography of the Very Rev. Lord MacLeod MC, DD, which has been commissioned by Collins.

The late Rev. Harald Mooney was the minister of Deerness Parish Church from 1929 through to its linking with St Andrews in 1974, after which he continued as minister of the linked parishes until his retirement in 1984. He was a graduate of Edinburgh University, and grew up in Kirkwall in a household where learning was much prized, his father John Mooney being the author of a book on St Magnus Cathedral and of much scholarly work on many aspects of the building and its history. Harald Mooney himself wrote numerous historical articles, as well as the present guidebook to the Cathedral. He died in 1989.

The Very Rev. Professor Robert Craig was Moderator of the General Assembly of the Church of Scotland in 1986-87. He was Professor of Theology (1963-80) and Principal and Vice-Chancellor (1969-80) of the University of Zimbabwe; and Minister of St Andrew's Scots Memorial Church, Jerusalem, 1980-85. Professor Craig is a graduate of St Andrews University and of the Theological Seminary, New York, and holds honorary degrees from the universities of St Andrews, Witwatersrand, Natal, Birmingham and Zimbabwe. He was appointed CBE in 1981 for services to university education in Zimbabwe, and is the author of *Social Concern in the Thought of William Temple* (Gollancz, 1963). He was a British Army Chaplain from 1942 to 1947, and was mentioned in despatches in Normandy in June 1944.

Isobel Gardner, who provided the illustrations, is an artist living and working freelance in Orkney. She comes originally from Arbroath, and was formerly based in Edinburgh, where her work has been exhibited in various galleries. Her pictures are also on regular display at a gallery in Washington DC, and are in various private collections overseas.

The conference chairman throughout the proceedings was R.D. Kernohan, editor of *Life and Work*, the monthly record of the Church of Scotland. Mr Kernohan has First Class Honours degrees from Glasgow and Oxford Universities, and was at one time Assistant Editor of the *Glasgow Herald*, and thereafter its London Editor. He then served as Director of the Scottish Conservative Central Office, and was a freelance journalist and broadcaster before taking up his present post, which he has held for the past 17 years.

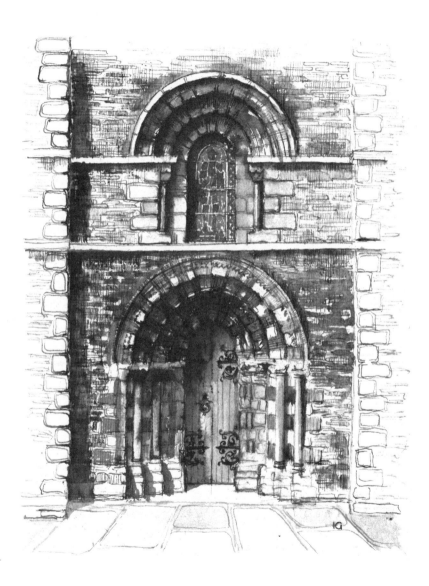